MW01196358

IMAGES
*of America*

# WASHINGTON DULLES
## INTERNATIONAL AIRPORT

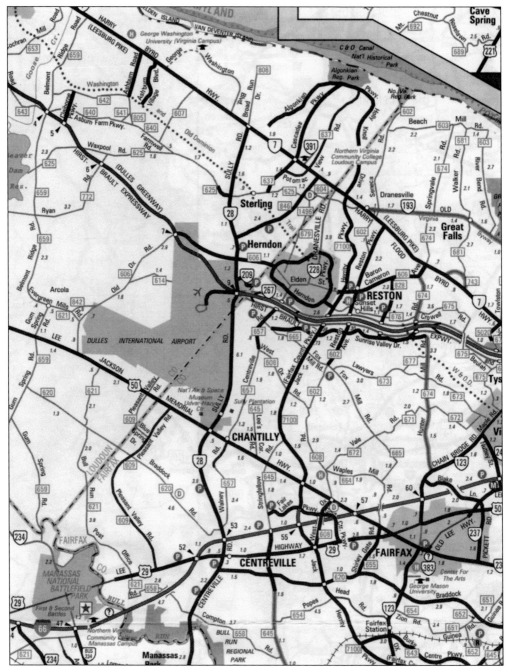

Pictured here is a map of the Northern Virginia area, which includes portions of Loudoun and Fairfax Counties and shows the location of Washington Dulles International Airport. It seems at times that all roads lead to the airport, and that what has taken place is more than what was expected. But did we really know what to expect?

IMAGES
*of America*

# WASHINGTON DULLES
## INTERNATIONAL AIRPORT

Margaret C. Peck

ARCADIA
PUBLISHING

Copyright © 2005 by Margaret C. Peck
ISBN 978-0-7385-1847-3

Published by Arcadia Publishing
Charleston, South Carolina

Printed in the United States of America

Library of Congress Catalog Card Number: 2005924317

For all general information contact Arcadia Publishing at:
Telephone 843-853-2070
Fax 843-853-0044
E-mail sales@arcadiapublishing.com
For customer service and orders:
Toll-Free 1-888-313-2665

Visit us on the Internet at www.arcadiapublishing.com

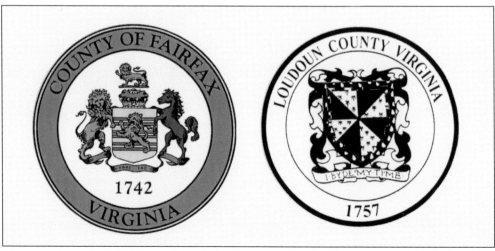

These are the seals for Fairfax and Loudoun Counties—Fairfax County was established in 1742, and Loudoun County was established in 1757.

# CONTENTS

# ACKNOWLEDGMENTS

The author would like to thank all the individuals who provided assistance while this book was being put together. Family, friends, and others have answered questions, loaned photographs, taken and processed photographs, and reviewed written material. A special thanks goes to Leo Schefer, president Washington Airports Task Force, and to the Metropolitan Washington Airports Authority for the use of photographs from their files. This help has truly made the book a community project.

This book is dedicated to my husband, Howard Benjamin Peck, and our children, Ann and Byron.

# FOREWORD

After the idea was proposed before 1957 of placing an airport at Burke, Virginia, and some acreage was purchased, a turn-around of ideas took place, and other areas were considered. In August 1957, Congress appropriated $12.5 million and told President Eisenhower to pick a site and buy some land for a jet-age airport to serve the nation's capital. That action triggered a chain of events that, 50 years later, still is having a profound effect on the entire metropolitan Washington area and its neighbors.

Modern commerce is global. Today's core employers locate where they have good global access. Just 20 years ago, the Dulles and Route 28 corridors, which intersect by Dulles Airport's front door, were an insignificant part of the regional economy. By 2005, these two corridors alone had become nearly one quarter of the entire metro region's economy. Forty percent of the region's jobs have been created since 1982, and nearly 70 percent of those jobs were located where companies had good access to Washington Dulles.

Our world is not static. Communities grow and prosper or they decline. Enjoy the past seen through these pages and relish the future. As you do so, please hold two thoughts in mind; Dulles, through its land, has strong links to the founding fathers and even stronger links to its current neighbors, with whom it tries to live in a state of harmony so far successfully, to the benefit of both. Secondly, our region was a birthplace for the nation and today, aided by Dulles, is a crucible for tomorrow's world.

Leo Schefer, President
Washington Airports Task Force
June 2005

# INTRODUCTION

With the story told in Images of America, *Washington Dulles International Airport*, I am sharing what I heard, read, and saw as a jet airport was planned and constructed and as it later changed the surrounding communities. As a new neighbor, Dulles played a large part in the community, and many photographs, slides, and newspaper clippings have been compiled here.

The 1950s were a peaceful time in the Virginia countryside beyond the nation's capital. Soldiers from World War II had long-since returned to their homes and places of work. Silk stockings, sugar, gasoline, and other commodities that were scarce during the war no longer needed to be purchased with stamps, while churches, schools, and family gatherings were providing a large part of family social life. It was indeed a good time to live in the area. But there was background talk in Washington, which would eventually deliver great changes to Loudoun and Fairfax counties.

Airplanes, airports, and their history were familiar to residents in and around Washington, D.C. The Wright Brothers had trained the first military pilots at College Park, Maryland, and there was Washington Junction Airport, which never materialized, and Loudoun County's Blue Ridge Airfield. Hoover Field, located on the present Pentagon site just south of Washington, was opened in 1926. At Hoover, when a plane was coming in to land, a guard held a rope across the road to stop traffic. When the plane took off again, the same step was repeated. Friendship Airport (later Baltimore and Washington International Airport) and Washington National Airport (today Ronald Reagan Washington National Airport) followed Hoover Airfield. Construction for National Airport started in 1938 on a site picked by Pres. Franklin Roosevelt. This airport, which opened in June 1941, was modern in design with plenty of space for airplane activity. But by the late-1940s, news in Washington included words regarding a newer and larger airport in the Washington area, and by December 1957, Pres. Dwight Eisenhower was ready to make an announcement.

The community of Burke, Virginia, was first selected, the land was identified as suitable, and money was issued to begin acquiring property. One person to receive payment was Rose Sisson who packed up her farm and moved to Willard just west of the Fairfax County line. After Burke residents had complained loudly, and all aspects were reconsidered, it was decided that another location in Chantilly would require less work. Rose Sisson had to once more pack up her farm and move elsewhere.

It took a bit longer than planned to build Dulles Airport, and the cost was greater than originally stated. However when completed, the jet airport was outstanding, and the terminal was a magnificent structure. From the day of dedication to the present, changes have occurred as new buildings and various support services have been added. One of the latest changes has been to double the size of the terminal.

The images here tell a story of what took place in eastern Loudoun County and western Fairfax County. Though the changes were not by choice, we fell in step and watched the action take place. The story here tells a bit of before, during, and after Dulles Airport and the area from 1957 to 2005.

# *One*

# THE WAY WE WERE

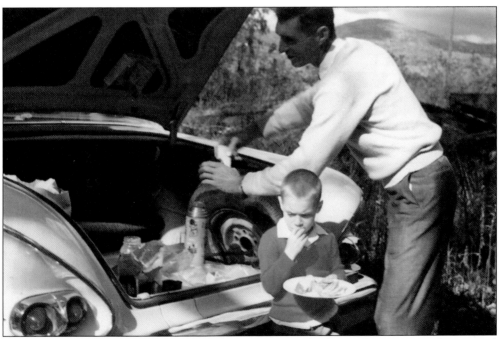

The period of time from the end of World War II into the late 1950s was one of peace and contentment. Life was good; northern Virginia's farming area was given top rating for quality of animals and production of milk. Non-farm-related jobs were available for those who needed employment, while churches and schools were actively engaged in teaching and serving. Among the simple activities locals often enjoyed was a Sunday afternoon ride in the surrounding countryside. Pictured here are a father and son enjoying a snack during a fall ride through Loudoun County. (PC.)

Fairfax County, established in 1742, was using the building to the left by 1799, and Loudoun County came into existence in 1757 with the building below available in 1761. Each county has had the very special qualities of interesting residents and beautiful land that, until fairly recent years, was predominantly used for agriculture. Citizens in each locality knew that prior to December 1957 that there was the possibility a new neighbor would begin to arrive in 1958; after all, talks had been taking place since the 1940s, and Congress had already purchased acreage. However, now they were changing their direction, and the look was suddenly toward western Fairfax and eastern Loudoun Counties. The residents were more or less unprepared for the changes that would take place when 10,000 acres were taken for a new airport located in eastern Loudoun County (75 percent) and western Fairfax County (25 percent). (Pen-and-ink drawing, left, by Gloria Matthews.) (PC.)

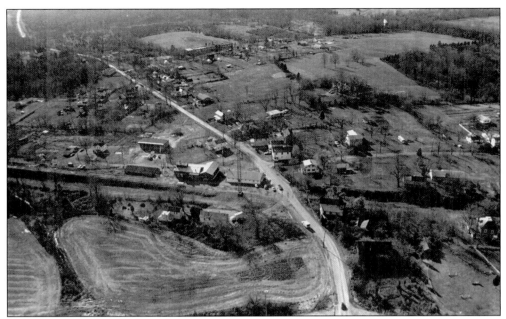

Shown here is an aerial view of Ashburn village and the surrounding Loudoun County countryside. The Washington and Old Dominion Railroad (W&OD) hasn't run trains since 1968, and today a biking and hiking trail goes from left to right on the bottom half of the photograph. County Route 66 cuts through from the bottom to the top. The commercial core of the county was close to the rail line with homes scattered about and beyond. (SW.)

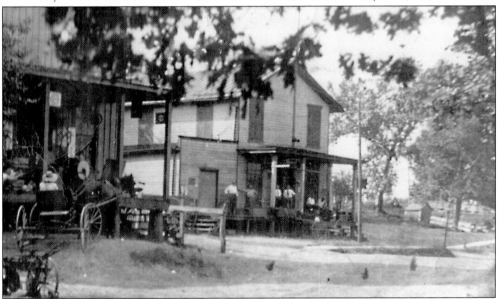

This is a photograph of Hutchison's store—later Partlow's—in Loudoun County's Ashburn village many years ago. Much remained unchanged with country stores for a long time, though some, like Partlow's, rebuilt across the road or nearby. Fairfax and Loudoun County each had a number of country stores in their villages, which also served as community gathering places for those who came to purchase groceries or those with time on their hands and a need to just visit. (SW.)

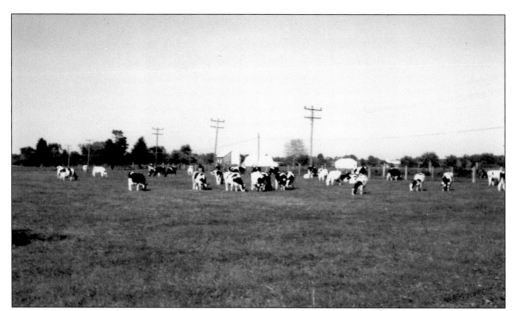

Western Fairfax County was still known as an outstanding agriculture/dairy-farming area at the time. New help had recently arrived for farmers by way of milk tank use instead of milk cans. Milking parlors and loafing sheds were now found on some farms. Some crops were being harvested with choppers instead of binders or hand labor, new balers no longer needed an individual to feed wires for the bales, and the large threshing machine was being used less often. (PC.)

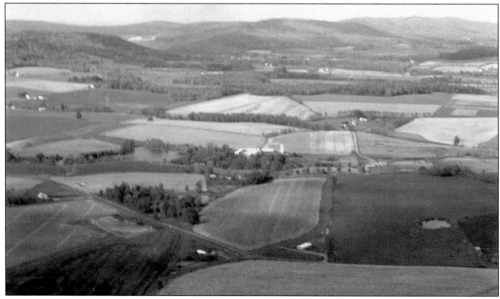

Loudoun County had always presented an eye-catching landscape, which moved from rolling fields in the east to foothills and mountains in the west. Dairy farms throughout the county were outstanding, and the herds contained blue ribbon-winning animals. Many acres in the western section supplied space for dairy farming and beef cattle. The foothills and mountain views were looked upon as an added prize for everyone's enjoyment, while homes and unique villages and towns were spread throughout the county. (PC.)

Pictured here is a farm with a wooded area as a backdrop. The field has had the hay cut and baled; this will be followed by at least another cutting before the season is over. Woods were necessary for early farm families, when nearly all homes were heated by a wood stove or wood furnace. In slack time, farmers and their workers felled trees that were later cut into desired lengths then still later split for their intended uses. (PC.)

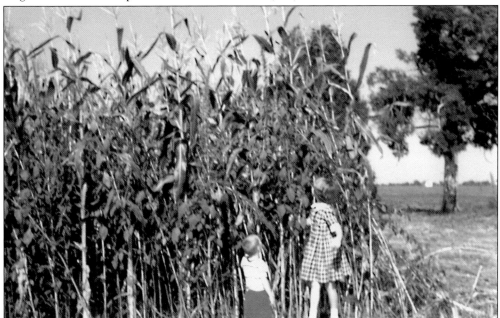

This photograph, taken in the fall, shows a corn field where harvesting had begun. It also shows the results of a good year, since rain at the right time had provided the growth needed for a quality stand. In this case, the corn was cut with a chopper, which then transferred the product into a wagon or truck. Here Ann Peck stands on corn stubble while her brother, Byron, watches with interest. (PC.)

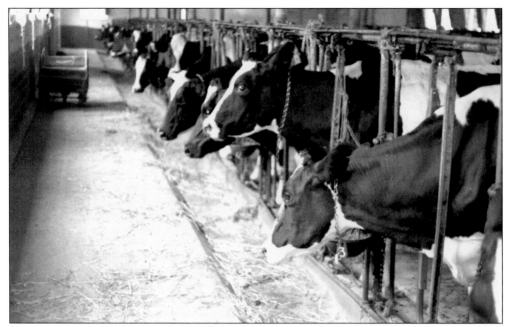

Holstein-Friesan dairy cows have just been fed and await the evening ritual of being milked. Hand milking was seldom done in either county at this time, since electric milking machines were in place at the majority of farms by 1950. These and other improvements made life a bit easier for the farmer and his family. The Holstein-Friesan breed provided a larger percentage of dairy cattle than other breeds in each county. (CL.)

Wheat, usually planted in September, should be tall and golden by July and ready to be harvested. This field did not yield its potential due to a severe storm just before harvest time; however, it has always been necessary for a farmer to accept what nature handed out. Many acres were planted each year, but there was no assurance the crop would have perfect results. (PC.)

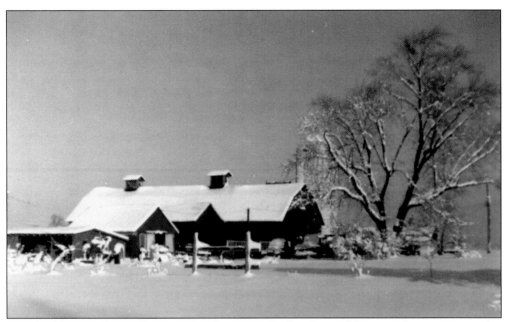

Farm buildings and grounds covered with snow make for a beautiful picture; however, snow also makes extra work for everyone on a farm. On a morning like this one, every chore takes a bit longer to perform be it starting a fire in the boiler in the dairy, carrying wood for the house fires, or cooking extra for a hearty breakfast. What delight it brought children to perhaps get a day off from school and play in the snow. (PC.)

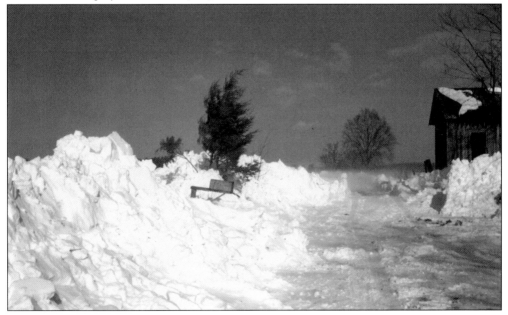

Weather always concerned farmers, but it also affected all who traveled or worked outside. Pictured here is the result of a heavy snow in the late 1950s when main roads received the attention, while lesser roads were given one lane with space to pull over from time to time. Pictured here is Monroe Street just north of West Ox Road in Fairfax County. Perhaps the many buildings which have been constructed in recent years make snow fence unnecessary. (PC.)

Summertime was for picnics and days of leisure on Sunday. Pictured here are several Cockerill siblings and their children resting after lunch on the lawn. Host Herman Kephart, who always had time for children, sits among them. In the background can be seen the result of a good season—extremely healthy gardens for the Kepharts and their neighbors, the Woodrow Wilsons. (PC.)

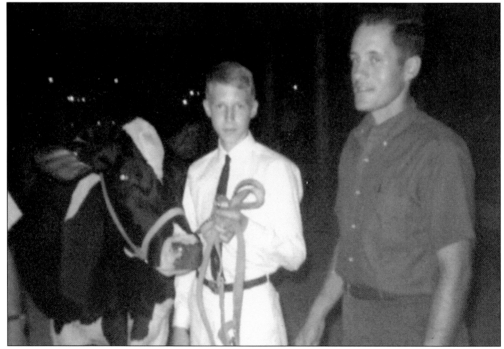

Tom Fletcher of Ashburn (left) has his picture taken with Loudoun County Extension Agent William Harrison. Tom was one of many young people in Loudoun County taking an active part in the 4-H dairy program. His family's dairy farm provided the opportunity to raise animals of his own and to show them. The Loudoun and Fairfax 4-H members enjoyed working to be the best at proper care for animals and being the winner in showmanship. (TF.)

Nearly every home set aside space for gardens; there was always a vegetable garden and most often a place for flowers too. It might be a set-aside space, a spot outside the door, or one or two rows in the vegetable garden. On a farm, the makings for healthy plants were always at hand from soil enrichments to directions on how to plant and care for your project. (PC.)

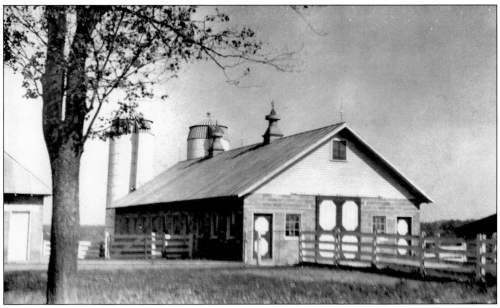

Pictured here is the barn at Sugarland Farm, which was located on the north end of Centreville/ Dranesville Road (today Route 228.) The large farm owned by Roscoe Crippen, who lived in Herndon, took in both sides of the highway. Crippen operated his farm for many years. After his death in 1952, another family member took over the dairy operation. Milk from Sugarland was shipped to the Washington market along with that from other area farmers. (TH.)

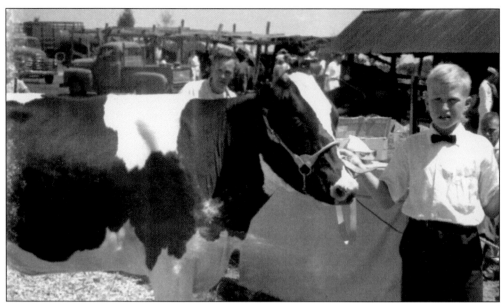

Dwight Peck is shown with his dairy animal at the Floris 4-H Fair in 1958. Local 4-H clubs provided interesting programs, which were and are available to both Loudoun and Fairfax County youth. Programs offered included material related to food, health, gardening, dairy and beef animals, and clothing. Today with a diminished farming world in this area, club members have branched out to include projects related to many other subjects including nature, photography, and crafts. (PC.)

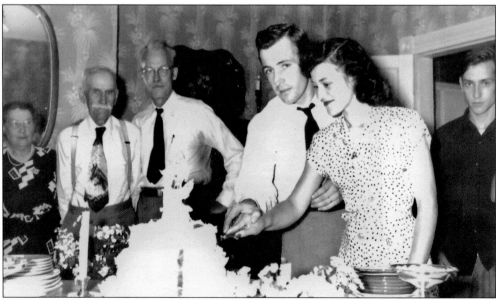

Two families, the Smiths of Sterling in Loudoun County and the Rectors of Pleasant Valley in Fairfax County, are joined with the marriage of Marie (Pete) Smith and James (Jim) Rector. Photographed here with the couple are some members of the Rector family, watching while they cut the wedding cake. Family members seen here from left to right are Toy Pauline Shirley Rupp, James Edward Rector, Russell Edward Rector, Jim and Pete, and Edward Rector. The wedding took place June 3, 1949. (BC.)

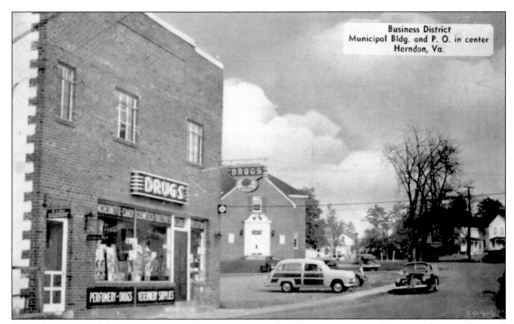

Business District
Municipal Bldg. and P. O. in center
Herndon, Va.

Herndon, one of four incorporated towns in Fairfax County, was a pleasant place to be and provided the basic needs of most families in the 1950s. Pictured here is the new drug store located on the southeast corner of Elden and Spring Streets. The south entrance of town hall or a municipal building (shown in the center) was used to enter the town offices. Station wagons like the one seen here were often the vehicles of choice. (TH.)

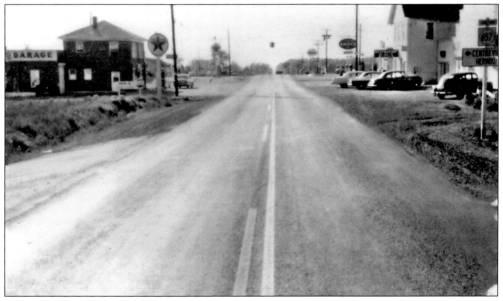

Chantilly Crossroads in 1950 was quiet, and movement was at a slow speed. Four corners and four main places of business identified the community, while Centreville was the next village to the south and Herndon to the north. As elsewhere in western Fairfax County, the major properties were farms. Downs Store supplied many shopping needs, but one could also go to Herndon and Fairfax or into Washington, D.C., which many did for additional shopping or medical needs. (BC.)

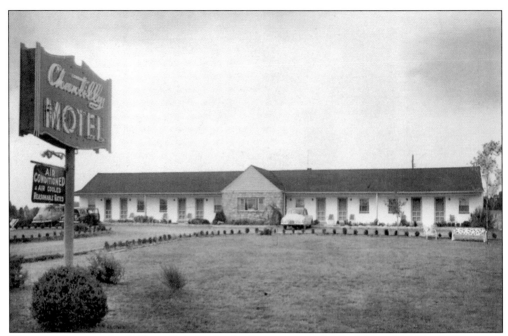

This is a photograph of Chantilly Motel, which was owned by Carlyle and Mildred Thompson and in operation from 1953 to 1961. The Thompsons stated they found the business to be both interesting and educational, and it provided an opportunity to meet kind, friendly, and exceptional people. Soon after the airport project began, when their entire motel was rented by engineers working at the airport, the tourist business was set aside. (BC.)

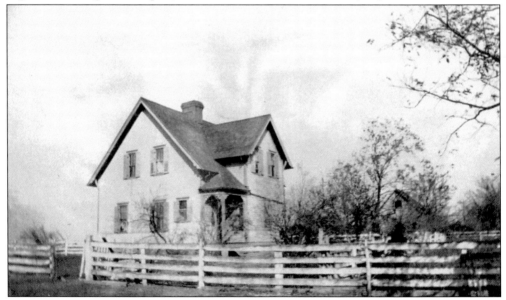

Pictured here is a house at Leeton, the W. W. Wagstaff farm, which was located at Chantilly. This house was referred to by family members as the Seibold house and was located north of the barn and west of the main house. The family used this building in the fall when butchering took place. All of the buildings on this property were taken down, and the entire property became a part of Dulles Airport. (PC.)

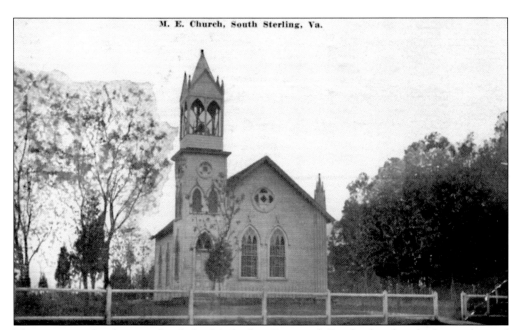

This is an early photograph of the Methodist Episcopal South church, which was located on Church Road in Sterling. Later the North and South identifications were dropped from Methodist churches. In 1983, the growing and active Sterling congregation moved into a new church on East Church Road in Sterling Park. Members of early Sterling families still attend the church. (PC.)

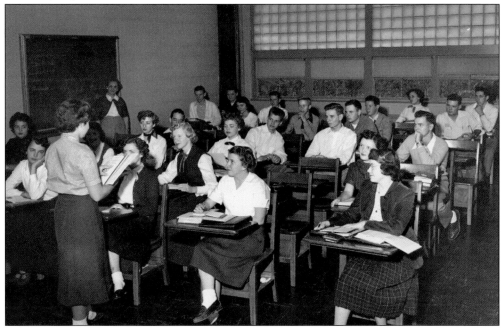

Katherine White (standing by the wall) taught English classes at Herndon High School for around 30 years. She loved the subject she taught and had many students who remembered her as a special individual. Bankers, doctors, lawyers, teachers, merchants, and others from any and all professions emerged from her classes. Pictured here are students in a mid-1950s class. (TH.)

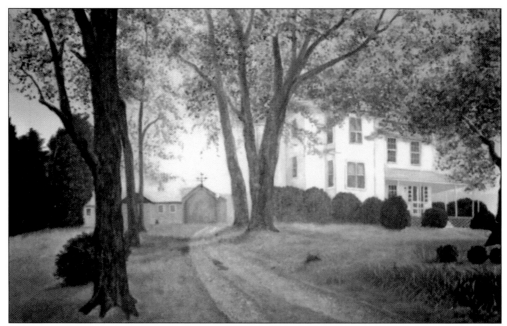

The home in this painting began as a log house in the early 19th century. Many years later, the building was enlarged and added to in order to provide a home for the Joseph Murphy family of Floris. The Murphys, like so many other landholders in the Herndon area, ran a dairy operation at their farm. Although the Murphy farm had only a token amount of land taken for the airport, the entire tract was later sold for development. (HM.)

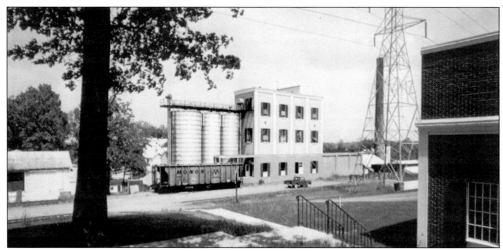

The land at Sunset Hills, today Reston, provided grain for the Bowman's distillery for years, and their dairy operation was one of the larger ones in the area. Between the two business operations, a large number of workers were needed, thereby providing employment and income to many in the community. Early on, A. Smith Bowman Sr. presented the idea of the Fairfax Hunt, people were interested, and a group was formed. Today the hunt continues, though their activities are held elsewhere. (PC.)

# Two

# A Project's Beginning

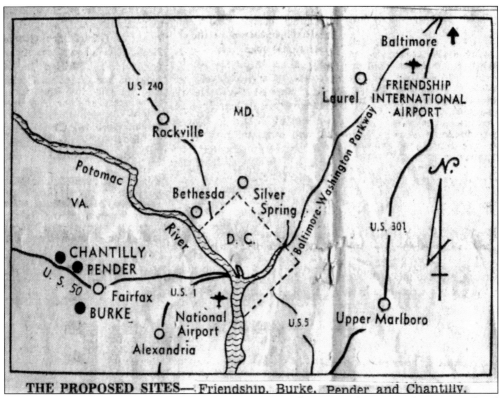

**THE PROPOSED SITES—** Friendship, Burke, Pender and Chantilly.

This drawing shows the area around Washington, D.C., where several sites were being considered as a location for a jet airport. Available information reported that the airport would be an up-to-date and top-of-the-line facility that would handle jet flights as well as provide other needed support services. The original location selected at Burke did not prove to be the best choice, and anyway, the people did not want it. (PC.)

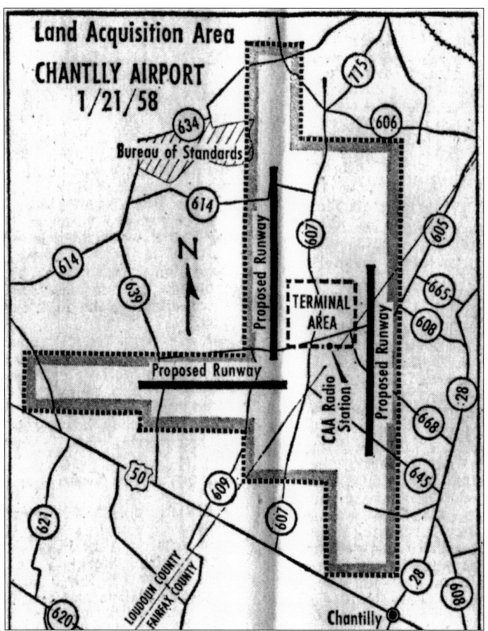

Land Acquisition Area
CHANTLLY AIRPORT
1/21/58

Bureau of Standards

Proposed Runway

Proposed Runway

Proposed Runway

N

TERMINAL AREA

CAA Radio Station

LOUDOUN COUNTY
FAIRFAX COUNTY

Chantilly

Pictured here is a sketch of the area where the new airport would be placed. The drawing shows all state and county roads, and each is marked with its number. The outline for the airport boundaries and the basic location for the proposed runways and the terminal are also shown. This was the first drawing available to the public and was in the *Washington Post* on January 21, 1958. The larger portion of the state-of-the-art airport is shown in Loudoun County, with a lesser amount of acreage taken from Fairfax County. Close to where the terminal was to be placed was Blue Ridge Airfield, which was started by Harry (Bud) Sager of Herndon. The field was on the Kirkwood family farm in the Willard community and had been used by a number of local individuals when learning to fly. The landing strip closed after World War II started. (PC.)

# Owners of Chantilly Land To Be Bought for Airport

Following is a list issued by the Civil Aeronautics Administration of property owners whose acreage will be affected by the acquisition of land for Washington's second airport at Chantilly, Va. The site includes land in both Loudoun and Fairfax Counties.

## FAIRFAX COUNTY

*Fairfax Tax Map 34*
Coates, Betty
Smith, Gladys B.
Lawson, Nancy Coates
Coates, Betty
Wilson, Gilmer L.
Wilson, Howard & Lillian Bowles Wilson
Points, McKinley Jr.
Grimes, Evert & L. Alice
Norris, Jake
Travis, Lewis & Jean Smith
Poston, James L. & Eula
Nolting, Frederick E. Jr. & Lindsay C.
Conner, Norman H.
Poston, Edgar W.
Poston, Grover C. & Irene B.
*Fairfax Tax Map 24*
Fleming, Gerald R. & Carrie L.
Wrenn, Robert
Cockerill, William Wesley & Carrie H.
Bailey, Pearl E.
Howell, H. H. & Irene H.
Gebeaux, Leo F. & Ruth W.
DeLay, John F. & Irene M.
Haines, Wilmer
Rector, Russell Edward & Irene B.
Brooks, George W. & Kathryn C.
Lohman, Wm. H. & Frieda H.
Hutchinson, Richard H.
Travis, Jean Smith & Lewis S.
Lee, Ernest
Smerkein, Fred T. & Quintin H. Lacey
Horton, Howard P. Jr.
Blair, Keith S. & Phyllis H.
Baker, Charles M. & Mary Lee
Peck, Frank E. & John D. & Howard B.
White, John W. & Louise
Behrens, Carl F. & Anna Jo W.
Peck, Frank E.
Peterson, Andrew M. & Loyola B.
Jackson, Fannie & John
Haselden, William V. & Dorothy H.
Harrison, M. Townsend & Dorothy A.
Herwig, Leopold Julius Heinrich
Morris, Rose B.
Middleton, John & William & Edna
McLaren, G. A.
Middleton, William D. & Sarah P.
*Fairfax Tax Map 15*
Murphy, Carroll M.
Beard, Joseph Edgar & John Woods Beard
Hyde, Leroy W. & Elizabeth K.
Fisher, Paul T. & Zennie G.
*Fairfax Tax Map 23*
Gebeaux, Leo F. & Ruth W.
Hutchison, H. Wade

## LOUDOUN COUNTY

*Loudoun Tax Map 93*
H. E. Alnard et ux
Nancy C. Kessell
Raymond E. Kramer
Fred W. Peterson et ux
S. L. & Louise B. Shanks
William D. F. Moran
Michael & Jessie Lorandelli
C. J. & Margaret B. Paschek
Ernest G. Cornett
John H. Gill et ux
James R. Baker
C. W. Marshall
Jessie May Moran
W. B. Patton
Lee Page Key et ux
Hunter L. Watson
*Loudoun Tax Map 94*
W. J. Hay
S. B. Cockerille
J. W. Hay
Glaiford S. Preper
M. L. Coleman
Gaiford S. Proper
Michael Lonardelli
L. B. Silvers

J. A. & Wilda Fay Tucker
H. W. Creel
William J. B. Cornett
Ralph L. Beitle
R. E. Wagstaff
Eugene V. Dabney
David H. Nargis
C. A. Richardson
Herbert R. Smallwood
Helen Ruth Barnard
Agnes Kirkwood
Michael Lorendelli
Philip J. Keller
L. E. Henry
S. A. & Lelua R. Lischinsky
W. R. Carroll
*Loudoun Tax Map 101*
B. Gitinder
Kenneth Olin Kennedy
Elsie King
H. J. Lane et ux
Fayse Bill
D. L. Hutchison
J. M. & Annie J. Lane
Alice D. Mills
Tony Kalenda
Enla Pollard
R. T. Mays et ux
*Loudoun Tax Map 102*
H. F. Hutchison
Edison H. Cramer
H. (?) Smith
C. A. Elossom
Stanley Strother
E. D. & Bessie E. Suddarth
Alton L. Clements et ux
John Middleton et al
Steve L. Sturgill et ux
John G. Paulding et ux
Mary Louise Blackwelder
Willie F. Mathers
Carl Lacy
G. M. & Marion K. Hearin
L. H. H. Blevins et ux
Hubert E. Lewis
Pearl E. Bailey
Wm. W. Cockerille
G. S. & Nina Raydell Jett
Wilbur Harris
E. W. Bailey
Stetson C. Newman et ux
W. C. & Mary Elizabeth Newman
Doris Stewart
Richard Henderson
William Taylor et al
Carl A. Thoms
Church
Anna Allen
Minnie & Maude Lee
Richard H. Newman
Joseph G. Bell et ux
Joseph G. Bell
Kenney Ashton
Noville Savoy
C. F. Cooper
H. B. & Ethel B. Zackrison
Robert B. Moore
B. J. Vierling et ux
Nat Corum
Harry Newman
Richard Newman
Thomas E. Newman et ux
I. H. Parham
Calvin Newman
Hazel Mills
*Loudoun Tax Map 103*
E. G. Germaine et al
James Kirkwood et ux
L. J. Carusille
D. D. & Alda W. Popovich
Burns N. Gibson et ux
Marita W. Scott
Julius Sirkio
Caroline Smith
Leon & Ruth S. Bloch
Annie Lee Jones
Holcomb & Edith Rogers
Donald Black et ux
Robert J. Aukers Jr.
Kerford S. Putnam
Henry & Margaret Bailey
L. W. Elizabeth K. Hyde
Caroline Smith
Taylor Henderson Est.
T. W. Davis et al
Richard H. Terrell
T. W. Davis et al
Thomas W. Davis et ux
Robert Wrenn
Leopold J. H. Herwig
Rose B. Morris
L. J. Carusillo
Leroy W. Hyde et ux
Joseph E. Beard
Middleton, John

The next announcement in the newspapers was this list: the names of the landowners whose property fell within the 10,000 acres needed to build a new, up-to-date airport. The list is divided by counties and gives the number for each of their tax maps. There were landowners who owned property in both Loudoun and Fairfax Counties, in some cases due to the boundary line having been changed. Later it became necessary for the government to take additional land. (PC.)

25

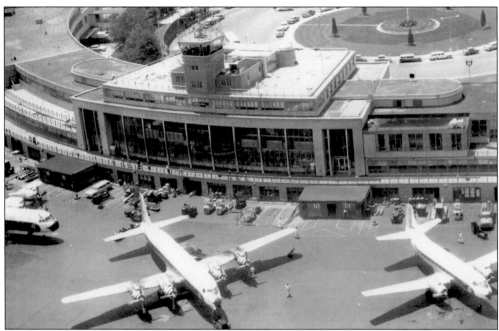

The Washington-Hoover Airport (1926–1941) was followed by Washington National Airport. Construction for National Airport started in 1938 on a site picked by Pres. Franklin Roosevelt. The airport, which opened in June 1941, was modern in design, had plenty of space for airplane activity, and provided a nice restaurant for the passengers and general public. National Airport was the larger of the two existing commercial airports in the Washington area. This photograph was taken sometime in the 1940s. (MWAA.)

Friendship Airport, built in 1950 in Maryland, was considered a fairly busy airport at the time. This photograph of Friendship was taken in the summer of 1957. While Friendship was listed in the complete study made of four sites in the metropolitan area considered for Dulles, Chantilly was chosen. The combination Loudoun/Fairfax location better answered the needs of the project. There were some in Maryland who did not think an airport was needed and in particular not one so close to Friendship. (PC.)

Leesburg's airport, pictured here, had its beginning on Edwards Ferry Road and was a project of radio personality Arthur Godfrey. Later Godfrey worked with the Town of Leesburg, and in an agreement that worked for both, the location was changed to Sycolin Road. Others used the airport early on for personal use and lessons, and there were always individuals who simply enjoyed watching airport activity. (PC.)

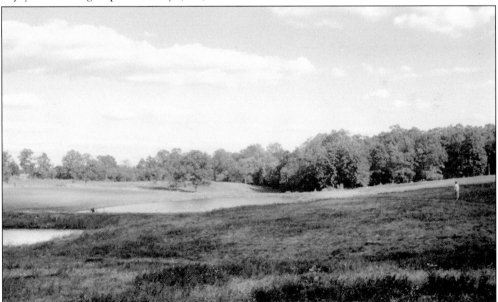

This beautiful setting provided ponds for skating in the winter, large shade trees as a perfect spot for a summer picnic, and a pasture for cows when needed. In addition, and perhaps best of all, there was a patch of junk growth filled with blackberry bushes, which provided berries as fresh fruit or delicious winter pies. It was a special part of the Peck farm. The dramatic changes to the land as construction began can be seen in the following pictures. (PC.)

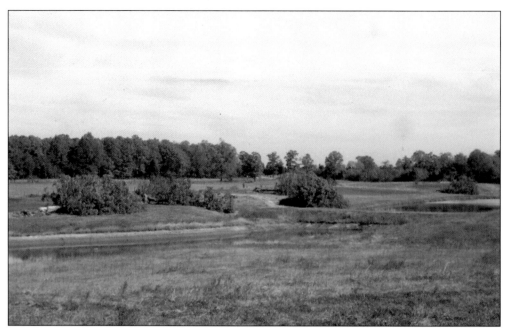

In this photograph, work has been started for clearing the previous shown 70-acre tract located off Wall Road. Some oak trees have been taken down, and following this, the ponds would be drained and the ground worked. The sod and soil would become one, and the space would later provide the setting for a portion of the approach lights. (PC.)

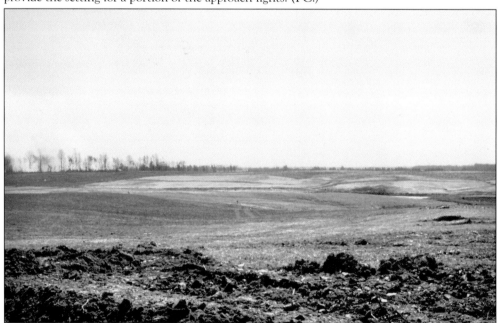

The large shade trees and all other growth have been completely removed done so with a hearty push from bulldozers. In this photograph, some of the surrounding tree line (upper left) can be seen still burning. Sully Road would be constructed east of this property, then later an assortment of trees—over one million—would be planted to deaden a portion of the noise from the airport. (PC.)

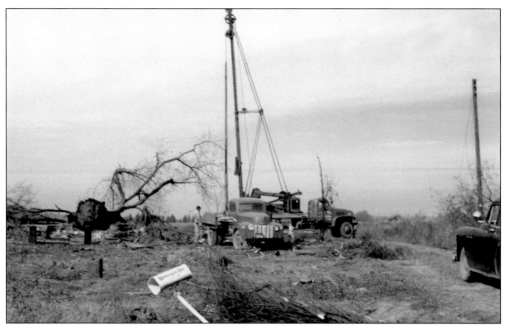

Shown here are the remains of the Popovich farm off Willard Road. The house has already been taken down and the remaining parts most likely destroyed by fire. All that remains at this point are trees, which have been downed but not yet set afire. The well pipe is being pulled to remove it completely, so it will not be dug into later. It is evident the *Washington Post* will deliver no additional papers here. (PC.)

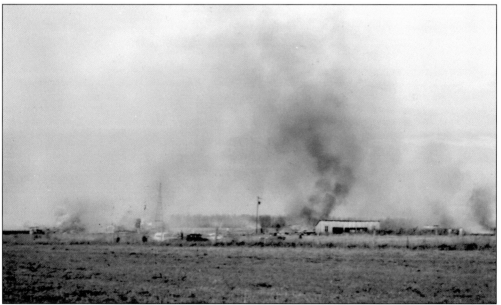

Not all buildings were pushed over; some were set on fire at once in order to dispose of them quickly. The remains of a windmill and a house are seen on the left, while other farm buildings are burning. Vehicles, old ones as well as those belonging to the workers, are parked along the fence. This was the farm property of William and Dorothy Heselden; William worked elsewhere, but they did raise produce and turkeys for the market. (PC.)

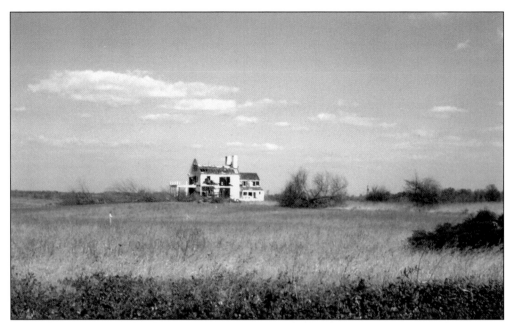

Dr. and Mrs. Leroy Hyde of Washington, D.C., owned a lovely country property off Horsepen Road where they spent weekends and vacations. This photograph shows what was left of the main house once the demolition process was started. A second house on the property, which had served as home for their employee, Marion Glascock, and his family was also removed. Buildings were either completely or partly torn down and then set afire. (PC.)

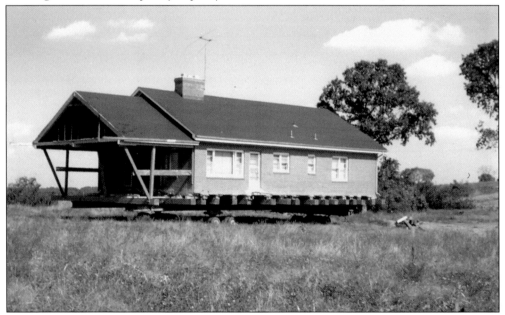

This photograph shows the former home of Townsend and Dorothy Harrison being moved off their property after they moved to Front Royal. The house was moved across the road to Mr. and Mrs. Gilbert McLearen's farm to be their new home. The McLearen's home fell within the airport property, as did a corner of the barn and some acreage. Mr. and Mrs. McLearen lived in this home until selling for development. Today a hotel and office buildings are there. (PC.)

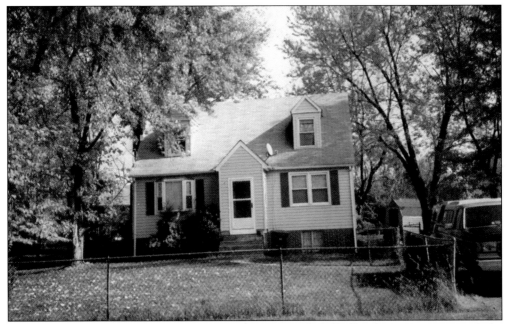

This small but attractive house once was a home in today's Dulles Airport acreage, and the house was one of several that were moved to the Chantilly and Herndon communities. The building was purchased and moved to Louise Avenue in the Ox Hill subdivision in Chantilly. Several houses from the Hunter Watson development, north of Route 50 and the Pleasant Valley area, were also moved to new locations. (ML.)

This photograph shows another house, which was home at one time to a family living in today's Dulles Airport acreage. The building was made secure, removed from its foundation, placed on a frame and little by little moved to a new location. Crestview Drive in Herndon became the new address for this house, which continues today as a family home. (PC.)

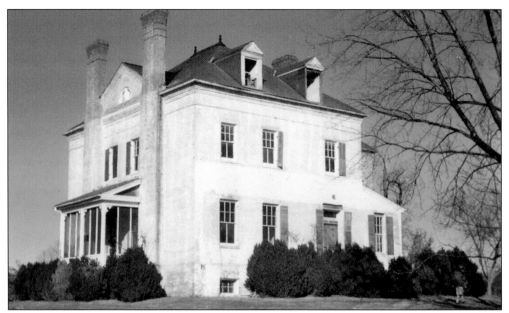

Pictured here is Leeton, the former W. W. Wagstaff family home and after 1941, the home of Mr. and Mrs. Lewis Travis and daughter, Sidney. Mr. Travis stated in a news article that he "had been looking forward to seeing their daughter come down the staircase at Leeton on the day she would have married." This house was built later than the one at Sully Plantation; even though an effort was made to save both structures, Leeton was lost. (PC.)

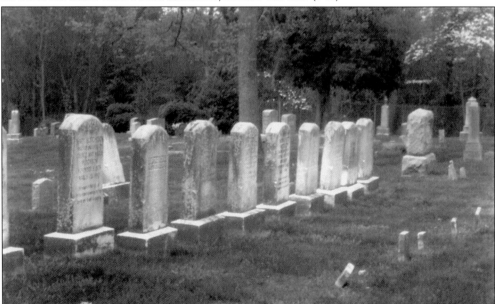

In addition to basic work at the airport, there was the job of moving a large number of graves from family, church, or community cemeteries. J. Berkley Green, owner of Green Funeral Home in Herndon, agreed to take on this responsibility. Green made the necessary arrangements with family members, churches, or legal representatives to move the graves elsewhere. This photograph shows a section in Chestnut Grove Cemetery (Herndon) where some of the graves were moved. (PC.)

In this field, some trees have been taken down, while others would soon follow. After the trees and brush were pushed aside by a bulldozer, they were set afire. Good use was made of old discarded vehicle tires when the burning process took place. The large piles of tires were used to keep the fire going. Burning tires, trees, and debris sent deep black billows of smoke circling upward to the sky. (PC.)

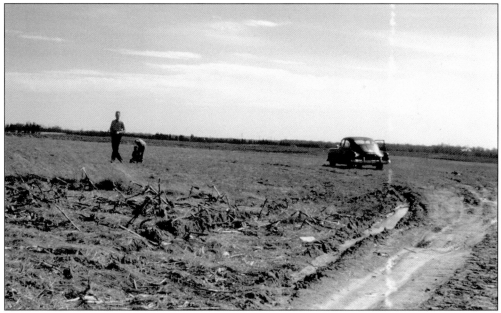

A last crop of corn was grown in the field on the left in 1957. Somehow it seemed necessary to ride about, take a look, and check to see what was taking place. When the visitors were not bothering anything on the land, families were more or less free to continue their watch. Young drivers often took advantage of the runways and practiced driving when they had an opportunity. (PC.)

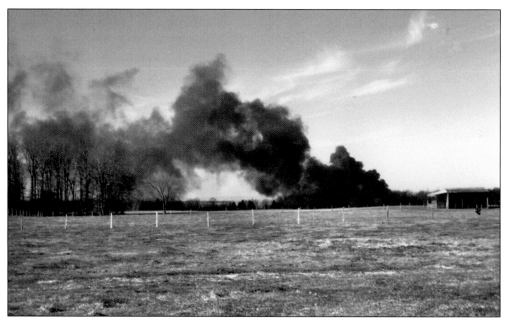

Because anti-pollution laws were not as strict in the 1950s as they are today, smoke from burning trees and tires moved into the sky. The shed on the right and the small grove of trees on the left would remain, as the airport property line is beyond one more field. The area where the burning is taking place is being cleared to make way for Sully Road, which started as two lanes and was later upgraded to four lanes. (PC.)

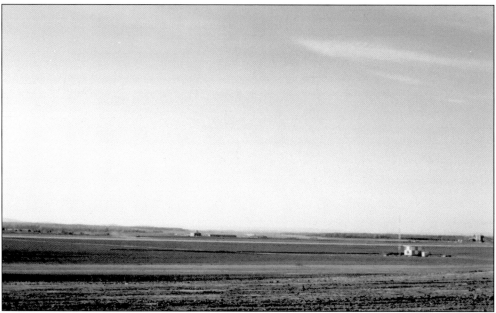

Far to the left in this scene is Maryland's Sugarloaf Mountain. This view looks north across the now barren fields, and to the right is a checkered box, which may be a piece of tracking or monitoring equipment. Beyond on the right are silos and a cement mixing plant. Fifty months from the beginning of all this activity, this scene would be completely different—the airport was open. (PC.)

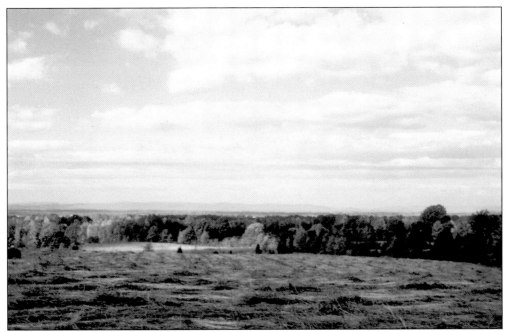

The foot hills of the mountains can be seen behind a large section of woods, and in front is a field of cut hay or orchard grass. This is an example of the outstanding views one could enjoy while discovering Loudoun and its natural beauty. This photograph was taken in the fall with colorful leaves on the trees. On a clear day, all of the mountain range could be seen. (PC.)

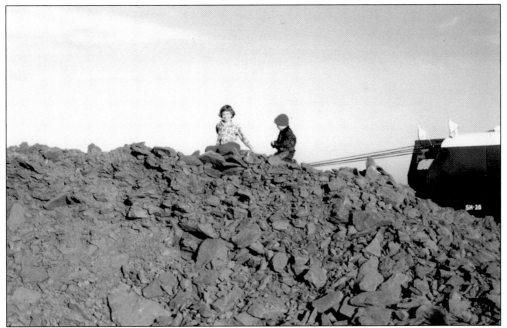

Machines ran all day long moving dirt, while drivers looked for stakes that marked their boundaries for their sections. In all, over 8 million cubic yards of dirt were moved on the site and most often, it seemed, from one place to another. Pictured here is a pile of dirt and shale serving as a playground for two children. (PC.)

Willard was a small community crossroads in Loudoun County from which one could leave to go anywhere in the world. There were single-family homes and farms, a school and a church, both black and white residents, and Blue Ridge Airfield, where several from the area learned to fly. Coleman School was a one-room school for students who lived in the Willard community. The school had closed before 1958, but at this time, the building still remains. (PC.)

This is Shiloh Church, which was located in the community of Willard. A red, white, and blue sign has been posted on the building next to the door because this site was included in land set aside for the new airport. A small congregation of black members had met here for many years, and some members had homes close by. The small cemetery located adjacent to the church contained graves that were relocated by Green Funeral Home. (PC.)

# *Three*

# MACHINES, RUNWAYS, AND ROADS

The largest machine to arrive for work at Chantilly (Dulles) Airport came on the W&OD Railroad and needed some assembly in Herndon. When ready, the machine was driven out Centreville Road to Coppermine Road, where a problem developed, it was unable to navigate the corner, and then there was a flat tire to be considered. After a great deal of discussion, a plan was worked out. This machine was important because it was capable of moving 100 cubic yards of soil in one swipe. In order to keep the machine moving, diesel generators supplied power to electric motors for each of the wheels on the machine. (PC.)

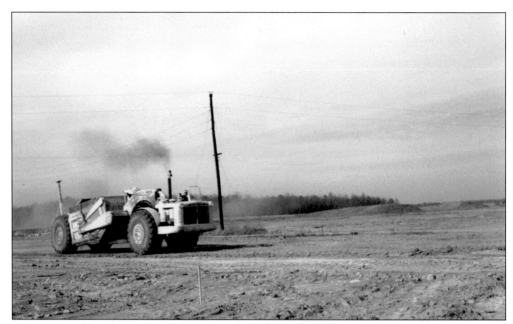

With some old utility poles and wires still in place, this scraper, or pan, works an assigned area. The machine, driven by two diesel engines, was manufactured by General Motors. Flagged stakes mark the section this driver is working in. The woods in the background would remain, while all soil pictured would be leveled. As the machines went back and forth all day a droning, sound was carried forth in the air. (PC.)

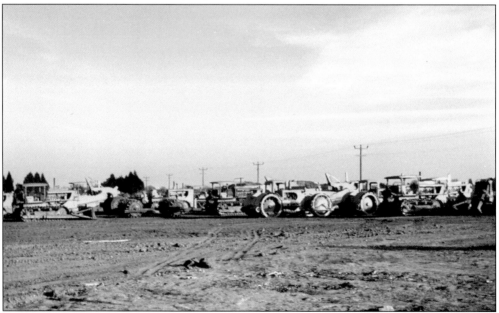

This photograph shows a variety of ground machines parked and waiting for the next day's work. These scrapers, bulldozers, and compactors were made by the Caterpillar Company. Each machine was designed to carry out a specific type of work, soil removal, or ground preparation, for the project, which was beginning to take shape. Long days were worked, and although there was strike talk at one time, it never took place. (PC.)

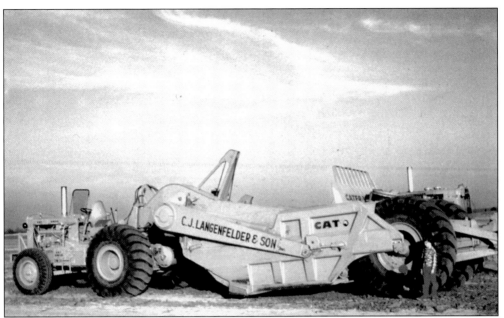

C. J. Langenfelder and Son had the contract for clearing and grading the land, creating drainage, and paving the runways. This, their largest machine, consisted of a rubber-tired tractor pulling a large scraper. Here it is parked for the weekend, when visitors descended on the site. They were interested not only in what was taking place on their former farm fields but also activities in general. (PC.)

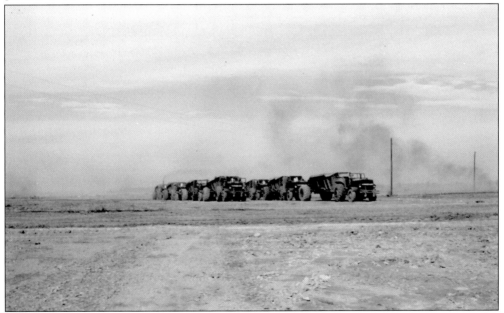

As was usually done, this fleet of bottom dump trucks has been lined up and parked until needed for the next section to be worked or perhaps the next day's work. This is another type of truck manufactured by General Motors. As can been seen from the photographs, this location was chosen for the airport project in part due to the more-or-less-level land that would have to be worked. (PC.)

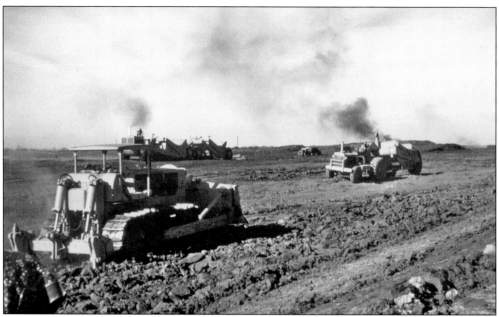

This photograph shows the constant movement of machines, bulldozers, and pans. It would have been difficult to keep track of the number of trips the vehicles made in a given day or what might turn up as they went back and forth. On one occasion after some blasting, pits of rock-encrusted bones were found and identified by a Smithsonian staff member. The bones were from an alligator-like creature that roamed the area during earlier years. (PC.)

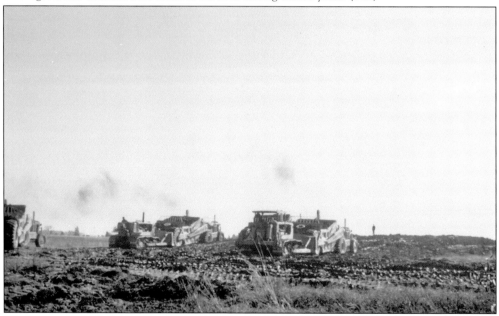

Working more or less in tandem, bulldozers and pans worked back and forth to create a surface suitable for building runways. It took two years of bulldozing and grading to prepare all of the land. At one point, rains held up the work, and in the winter of 1961, 52 inches of snow fell, which did not help the construction. Later when finishing up, dry weather slowed the job of landscaping. (PC.)

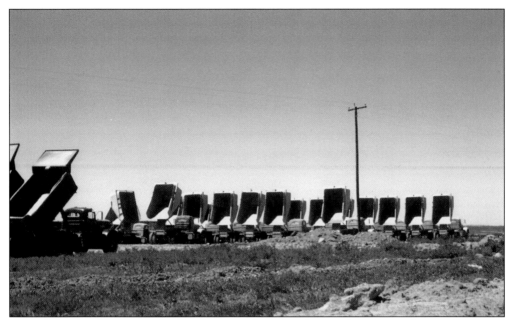

These dump trucks were used to haul cement from the plant to the areas working with cement needs. Langenfelder and Son and Western Company each set up materials plants in order to mix the sand, cement, and gravel used daily. Langenfelder dug and created a quarry for his use, and when the project was completed, he sold it to Chantilly Crushed Stone. The quarry continues in operation today. (PC.)

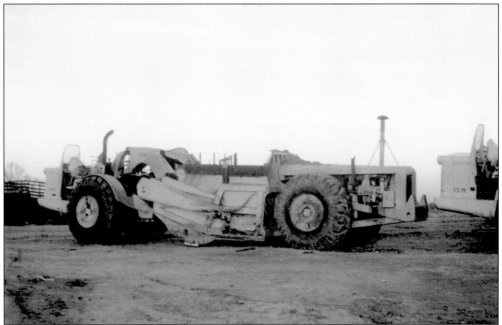

Shown here is another large machine similar to two others and perhaps third in size. These machines altogether cleared 1,200 acres of woodland, worked over 250 pieces of property, removed 580 buildings (300 homes), and took out 15 miles of secondary roads. This machine is a Caterpillar double-barrel scraper. (PC.)

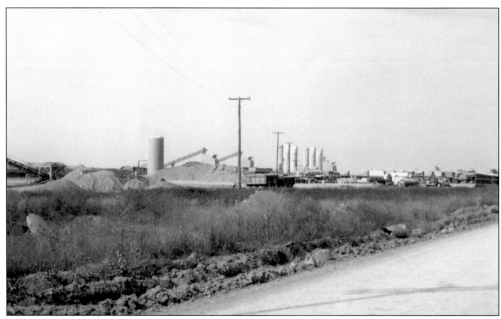

Western Contracting Company in Sioux City, Iowa, had the contract for the jet aprons and utilities. The company put up three silos, each with space enough to store 7,500 barrels of cement in addition to storage bins for sand and gravel. This scene of their plant shows the loading elevators. They quarried crushed stone on site, and then when work was completed, the quarry was filled with debris from the land surface. (PC.)

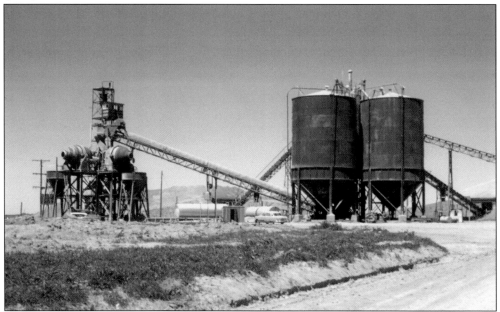

This photograph shows Western Contracting Company's cement-mixing plant for their paving work. Water for mixing the cement came from three 900-foot wells they dug. Water was needed each day to keep 35 cubic yards of cement flowing in order to cover 70 acres of cement for the jet parking aprons. Drinking water was brought in from Chantilly during construction; later water for the airport came from the Fairfax County Water Authority. (PC.)

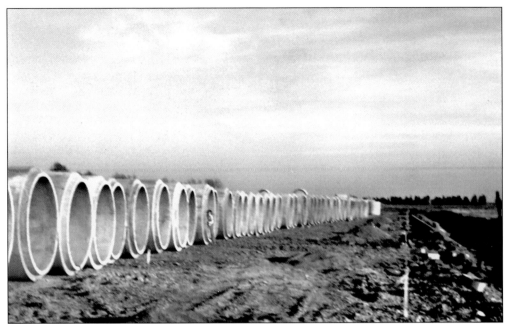

Huge cement storm tiles were moved in and lined up. It took time for everyone to be happy with the layout for the storm water, sewage, and fuel lines. Some residents in the Chantilly area were concerned with the thought that fuel lines might go across their lands. Sewer plant plans were made then stopped, as Congress took different steps, and all was eventually worked out. (PC.)

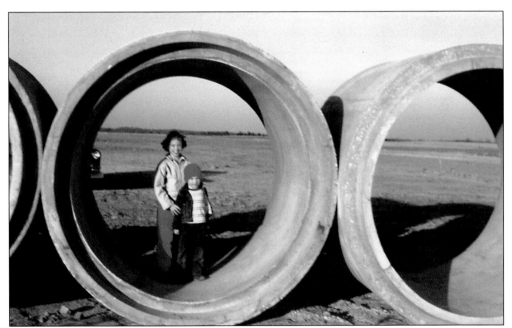

While locals walked and looked, their children saw the airport as a new and interesting playground, playing hide and seek among the tile. Though they were huge and perfect for a photograph, it was not really a safe playground for any child. Sometimes locals did their inspections from the automobile, but always it was an interesting activity. (PC.)

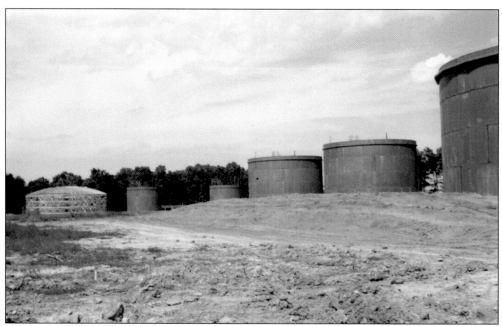

The huge tanks located on the east side of the airport along Sully Road are shown here. These tanks appear to be placed on acreage that had been a part of the Middleton farm on Frying Pan Road. The amount of Middleton farm land taken was 275 acres. That left 91 acres on which to continue operating a large dairy farm. (PC.)

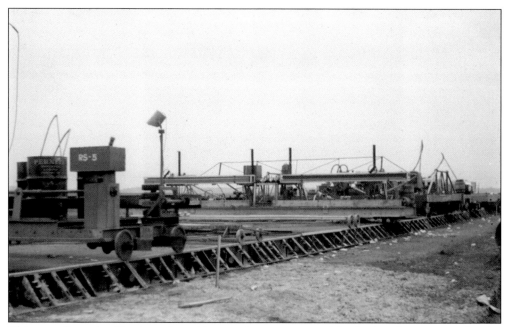

This complicated collection of machines and parts was used for laying the concrete for the runways. News accounts stated 100 tons of rocks were crushed each hour during the paving work in 1959. While all this was taking place, about 4,000 workers were employed for the airport project. During a peak period, about 2,000 were working. (PC.)

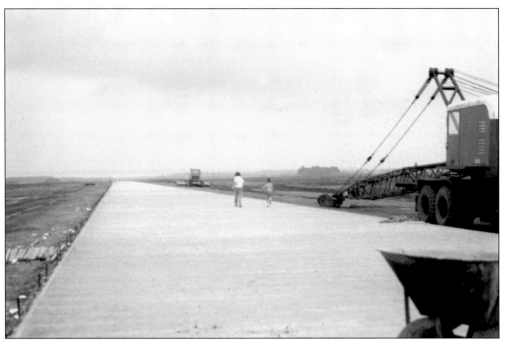

Tools as simple as a wheelbarrow or as complicated as a crane were used in the process of making runways. The variety of machines used at this project was a lesson for any worker. These companies that had contracts for the work knew what they were doing and how to do it. On this visit to the airport, children made use of the runway as a relay or practice track. (PC.)

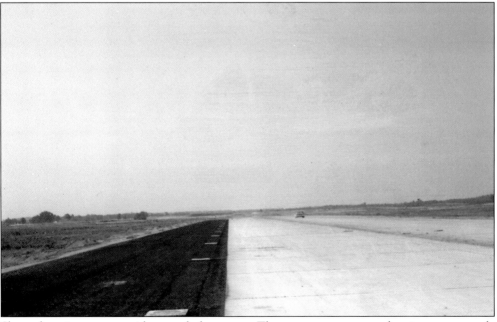

Shown here is a runway with an asphalt overrun. The runways, aprons, and taxiways were made of concrete and could handle aircraft weighing up to 500,000 pounds. Three runways were built: two were 11,5000 feet long and 150 feet wide; one was 10,000 feet long and 150 feet wide. There were also parallel strips for taxi in and out and diagonal strips for high speed turnouts. (PC.)

45

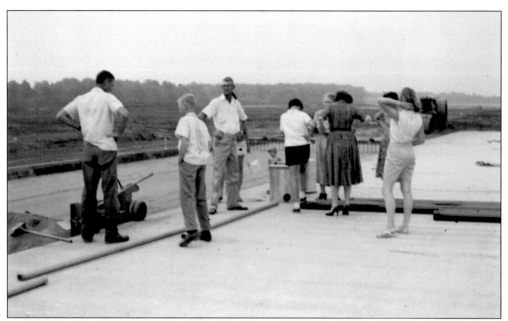

Local inspectors were kept busy with constant weekend checking on the previous week's work. Both close-by and out-of-town visitors discuss the progress that has taken place since their last visit. It was not the only activity in people's lives, but it certainly was an interesting one. In time, the freedom enjoyed to explore the site was stopped, but security was much more relaxed than it would be today. (PC.)

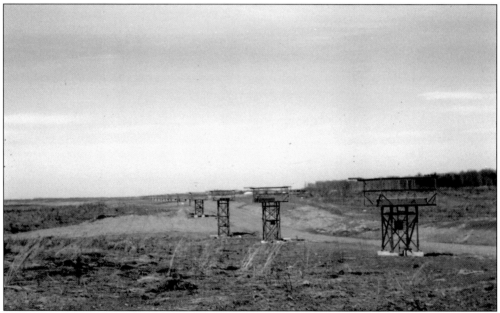

Approach lights and guiding lights for airline pilots are standard equipment at any airport. The orange brackets shown here are for runway 9 or 1 Right, depending on the direction of the landing, on the east side of the airport. They can be seen on the right when entering the road for the Udvar-Hazy Air Museum. The trees in the background are among the 1.5 million planted around the airport to help as a sound barrier. (PC.)

This photograph shows the power station located on the east side of the airport along the west side of Sully Road. Lines from this station carry electricity not only to the terminal but to all structures at the airport. Backup equipment was also put in place with immediate switch over to batteries in some situations and generators in others. (PC.)

A frenzy of work could be taking place at almost any time during the project. In this photograph, workers are studying what needs to be done, checking the layout of Sully Road, and finalizing groundwork in general. A simple power line does not answer all needs, but a power station with lines in all directions will. Lines strung along the east side of Sully Road were placed on large double poles. (PC.)

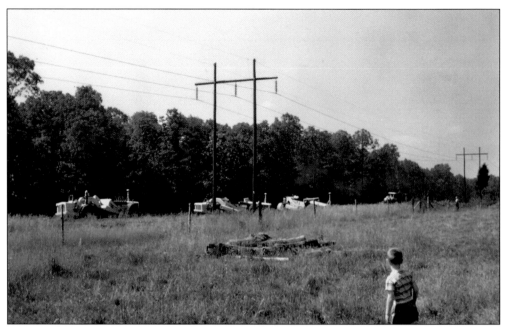

A young boy appears to marvel at the activity taking place but is keeping a safe distance from such large and loud machines. Farther along the fence row, his father takes a closer look. Though much development would later take place in Loudoun and Fairfax, no job would ever have the interesting variety of machines that were at work on this project. (PC.)

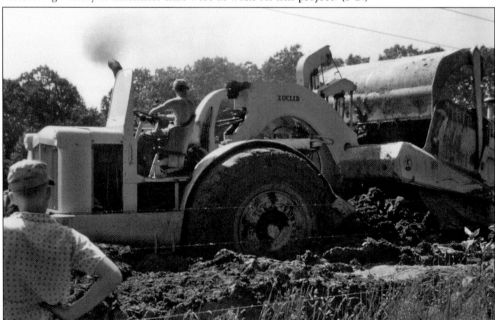

People watched as Sully Road gets started when a huge machine makes a drive through what had been farm fields. The road was laid out to run from Route 7 north of the airport entrance to Route 50 south of the entrance. This road was to have limited intersections and the airport access road would cross over Sully Road. Loudoun County marked future entrance sites, though Fairfax did not do so until later. (PC.)

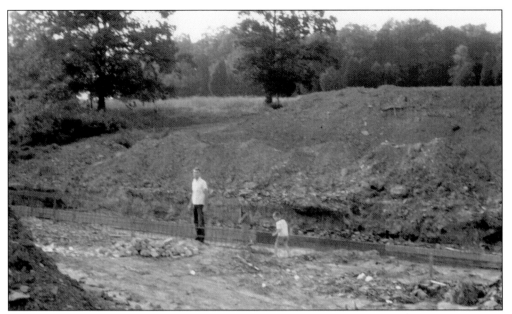

Before a road is built, present structures have to be undone. Here on Sully Road, the dig has taken place and other materials are being brought in, including rock for the road base. Out of curiosity to see what work is about to take place, a local family gets into the roadbed and take a look. Forms and rods to be used can be seen in the back of the roadbed. (PC.)

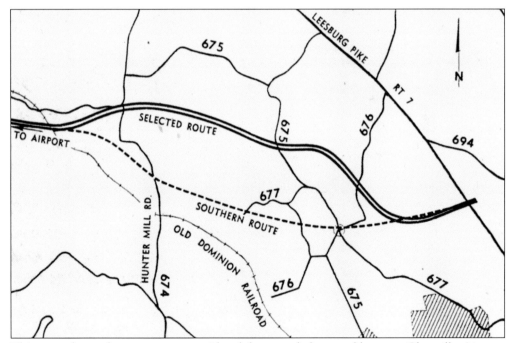

This map shows the two routes considered for a road that would run to Chantilly Airport. The parallel solid lines show what will be the access road between Leesburg Turnpike and the airport. The dotted line was the southern route, which was studied and discarded when the final selection was made by the Federal Aviation Authority. (PC.)

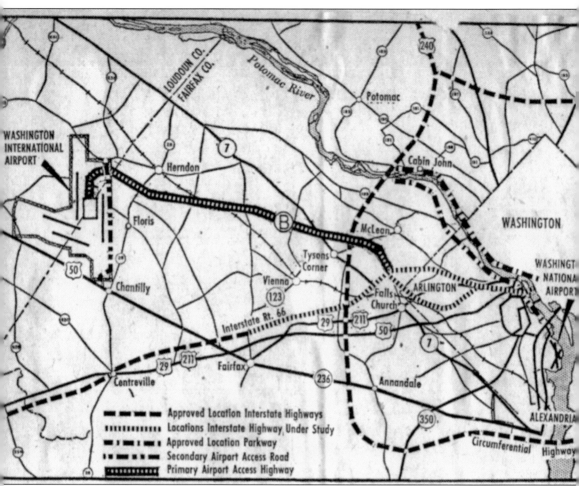

This map shows area roads and the layout for the new access road to the airport. Selection was made by the U.S. Commerce Department, and it was thought to be the most expensive choice of the four proposed routes, but the Civil Aeronautics Administration claimed it would be the cheapest in the long run through savings in mileage and time. There was a dispute over the paths the north and south routes would take, and community meetings were held, but in the end, Route B was chosen. Taking Route B left Ray and Richard Cockrill (father and son) who owned and operated the large dairy farm Hunter Oaks off Hunter Mill Road with an extra three miles to drive each day when hauling barn waste to the fields. This could seem even longer than three miles when traveling by tractor. When Richard and his family relocated to Loudoun County, the farm in Fairfax County became a sea of houses. (PC.)

An overpass was needed on Monroe Street, so once more, a home had to be given up. Ted and Florence Heriott had built a new home on Monroe Street across from their first Herndon home a few years earlier. When the space was needed, they constructed another new home using the same plan farther east on Fox Mill Road. The home they gave up was moved a little south and became a home for the Ollie Clark family. (PC.)

This photograph of Centreville Road looks south. The walls for the airport road overpass are in place and can be seen on each side of the road. On the left is Hollywood Farm, and on the right is a farm belonging to Mason Smith. The road would have gone just about in the middle of the Smith home. Buildings here and across the road were taken down. (PC.)

# Summary of Major Airport Contracts

| Job | Cost | Contractor |
| --- | --- | --- |
| Airport Land Acquisition | $ 7,100,000 | |
| Design and Engineering | 3,507,420 | Ammann & Whitney |
| Clearing Land | 466,213 | C. J. Langenfelder |
| Grading and Drainage | 5,847,645 | C. J. Langenfelder |
| Runway Paving | 12,493,475 | C. J. Langenfelder |
| Jet Apron and Utilities | 10,468,000 | Western Contracting |
| Terminal Structural Work | 4,432,000 | Corbetta Construction |
| Utility Buildings | 1,461,100 | Humphries & Harding |
| Heating Plant | 94,690 | Combustion Engineering |
| Air conditioning | 120,343 | Carrier Corporation |
| Access Road Land | 2,400,000 | |
| First Access Road Contract | 3,941,535 | C. J. Langenfelder |
| Second Access Road Contract | 4,334,492 | L. G. Defelice |
| Road Inside Airport | 1,845,028 | S. J. Groves |
| Mobil Lounge Development | 750,000 | Chrysler Corporation |
| Third Access Road Contract | 2,705,684 | Burkholder & Burkholder |
| Tree Planting | 25,720 | Ray Mathews Nurseries, Inc. |
| Terminal (Second Phase) | 7,934,500 | Humphries & Harding |
| Three Service Buildings | 1,474,776 | John Tester & Sons |
| 3.2 Miles Perimeter Road | 577,253 | Burkholder & Burkholder |
| Ground Radar Equipment | 230,000 | Culter - Hammar, Inc. |
| Fuel System Testing | 50,037 | Allied Aviation Fueling |
| 20 Mobile Lounges | 4,654,660 | Chrysler Corporation |
| Lounge Docks | 1,641,000 | Grunley-Walsh Construction |
| | | |
| TOTAL | 76,805,571 | |

This is a listing of major contracts when the construction of the airport began. The information given tells the job to be done, the figured cost, and the name of the contractor or company. The final tally may have differed from that stated here because the overall cost of the airport project exceeded the original amount. In addition to this listing, there were lesser contracts for various other work done at the airport. Several dates were given for the date the project would be finished. Finally the November 16–17, 1962, date worked, and everyone had to admit a truly outstanding job had been done. On Thanksgiving Day following the opening, as many automobiles as could be fitted on the airport road made a trip to Dulles. Hundreds ate dinner and took family and friends for a ride to see the new airport. It was a long afternoon and a big traffic jam. (PC.)

## *Four*

# A DESIGNER'S DREAM

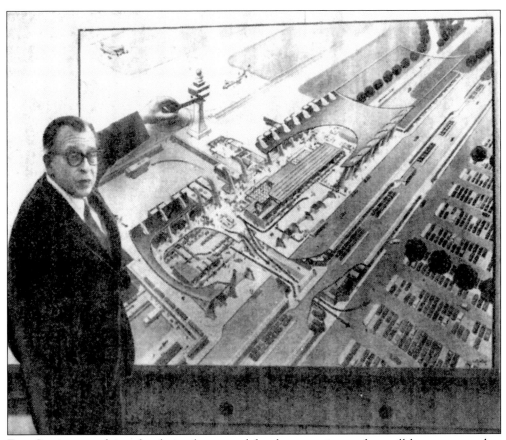

Eero Saarinen explains the design he created for the new airport that will be constructed at Chantilly, Virginia. His work was different and modern; some liked the design for the terminal while others did not care for it. Nevertheless Saarinen thought this was the best work he had ever done, so it is sad he did not live to see the finished project. (PC.)

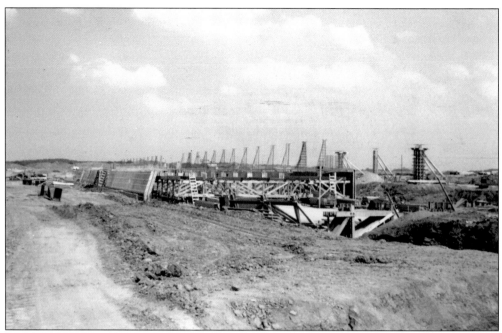

In the beginning, the terminal building was much like the ugly duckling that later turned into a swan, for there was certainly no beauty involved in raw dirt and piles of supplies. First the footings were poured then followed framing and forms for the cement that would become walls and floors. Pictured here is the terminal with arched pillars and the partially constructed tower. (PC.)

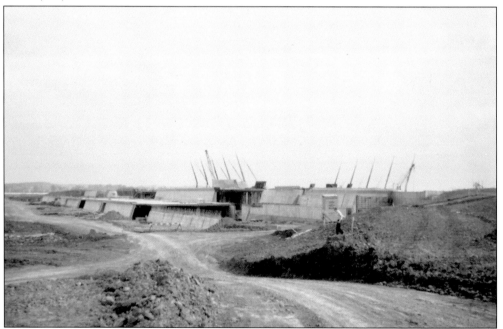

Once the concrete had cured, the forms were removed. In this photograph, the openings for the large glass doors on ground level visitors walk through today can be seen. On the right are the metal forms for the slim, outward-canted pillars that will hold the roof. (PC.)

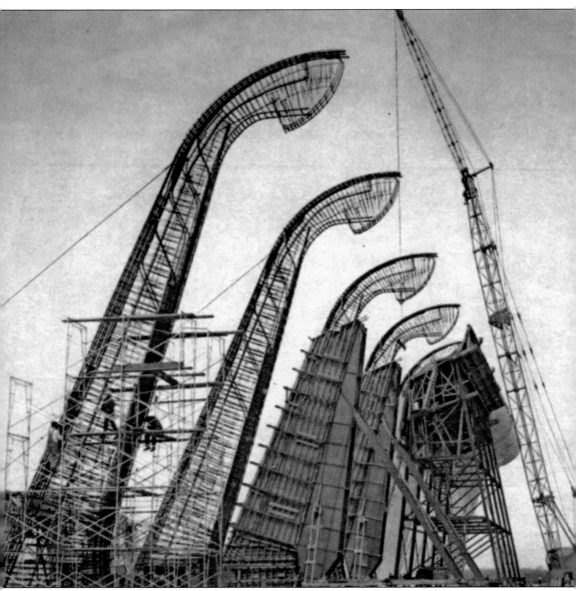

Here the beginnings of the terminal walls are in many stages. The forms are frames made from rebar welded together. They are made stronger by inserts of iron into each pillar. At the end of the line, the forms have had cement added to the exterior to finish them off. On the right is a crane used for lifting the center pieces to help get them in place. On the left, a number of men work at different levels. The curve of the roof line where it makes a sweep over and under to achieve the finished form can be seen to the far right. The crane is being used to lift the heavy pieces that will make the end result a strong building, even though it looks like an animal from long ago! (PC.)

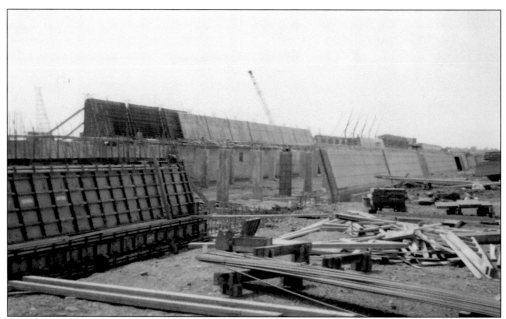

This photograph shows the continuation of the walls where, on the north or back side, another level has been added. Forms still being used are on the left, and lumber from forms that has been broken down is in the front. The shell of the terminal was done by Corbetter Construction Company of New York. The remainder of the building was contracted to Humphries and Harding of Washington. (PC.)

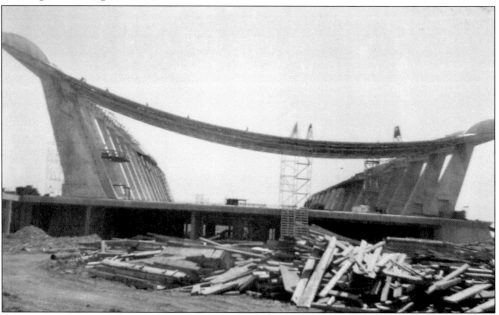

The roof, as shown here, looks like a hammock hung between the two incomplete walls. On the ground level, the basement area is visible. This was the appearance of the building in August 1961. One bystander shared his thoughts and stated "the building and airport will not be completed on time." In a sense he was right, because the opening date was changed several times. (ML.)

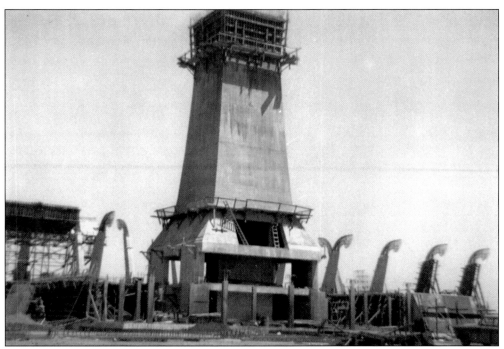

The tower grows, and the shape of a building takes form. The tower's appearance is similar to some of the construction at a nuclear-plant site or a large outdoor fireplace. While the construction was taking place and a change had occurred in administrations, there were words of mismanagement, increased cost, and a changing completion date. (ML.)

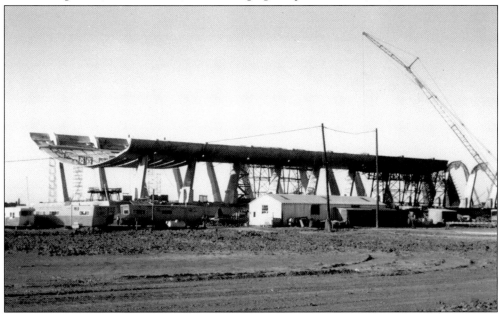

As shown here, all vertical supports are in place, and the roof has been placed in the required position. It makes one think of the sweep of an airplane wing. Although this roof caused the workers a considerable amount of trouble when finished, it could withstand almost anything, and even if a suspension cable broke, it would not come down. (PC.)

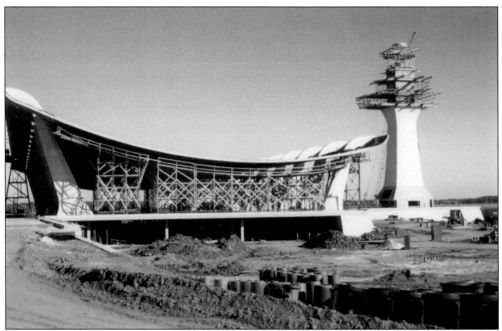

In this photograph, the roof is completed and hangs securely between the projected pillars. The tower has framing in place for the two balcony-like ledges, and the radar globe will be placed on its top. Drain tile, seen in the front of the photograph, will be placed in the open ditch. There were a lot of tense moments when the glass sections were put in the building. (PC.)

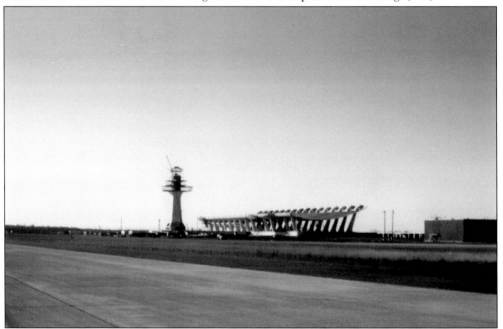

The terminal and tower are seen from the south side of the building. On the north side, the beginning of office construction can be seen. In that direction, a motel, another similar office building, and a number of warehouses and other structures would be constructed. As time has gone on, many structures have been placed there. (PC.)

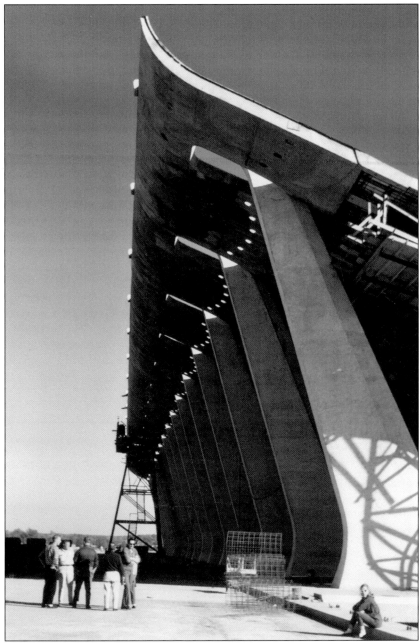

When looking at this photograph, it is evident the day is Sunday, because all airport construction workers have the day off, and the locals have taken over. A discussion appears to be taking place regarding the merits of the building. Close-by residents and others from out of the area came to observe the progress of this huge undertaking. When the building was finished and the airport opened, the first arriving passenger was an 86-year-old woman from Kansas, and the first plane to touch down was an Eastern Airline plane. There were no major problems the first day and very few minor ones. The airport manager was W. E. Cullinan Jr. President Eisenhower resolved the controversy that took place over the airport's name by naming it after John Foster Dulles, and Rep. Joel Broyhill lost out. Broyhill wanted the name to remain Chantilly. (PC.)

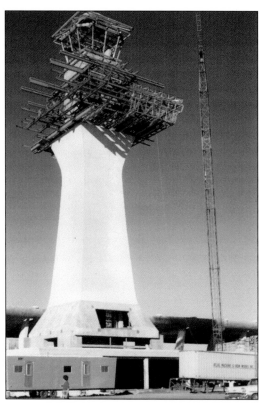

This photograph is a close-up of the tower and shows the walls with a white coat or top finish. Framing for the office space and observation floor or room is in place. The tower's height is 177 feet above ground level and offers an outstanding view of the airport layout and the countryside for those who work inside. (PC.)

With an almost completed terminal in the background, lounge drivers practice connecting to doors of different levels, which represent the different airlines. The ramp is shown projected out to provide a walkway to the airplane. The drivers also practiced on artificial snow in order to test for winter driving. Driving was a minor part of preparation; hooking up to the airplane was the big thing. (PC.)

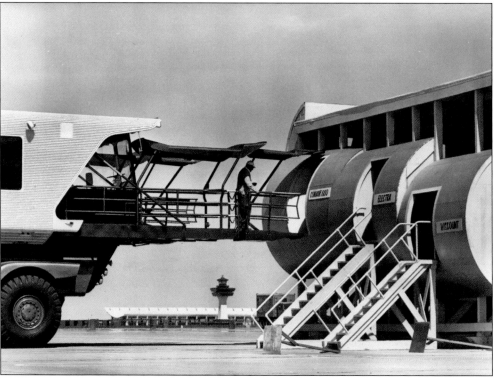

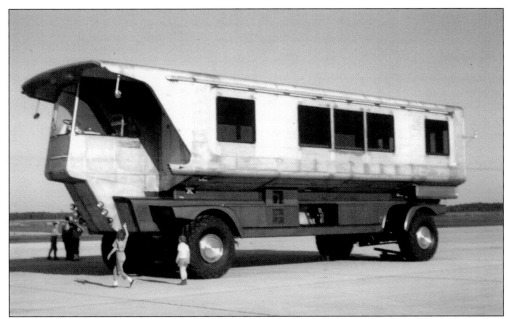

Local visitors are awed by the size of the mobile lounge that was brought in for practice. Each lounge would carry a high price tag, and 20 vehicles were to be ordered. The lounges, which were to go between the terminal and the airplanes, were referred to as rolling living rooms. The chassis for the lounge came from the Chrysler Corporation's plant in Detroit and the body from Philadelphia. The prototype was tested for 8,5000 hours before being used. (PC.)

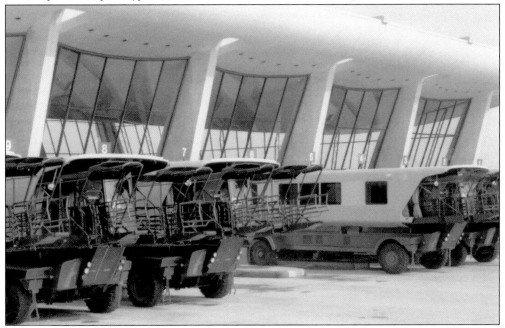

This photograph shows the southeast end of the terminal with several mobile lounges in place. Passengers walked through the terminal and into the docked vehicles. This was followed with a pleasant ride to the airplane. The modesty shields—canvas covers for the walkway sides—were put in place so there would be no flying up of ladies's skirts. (SF.)

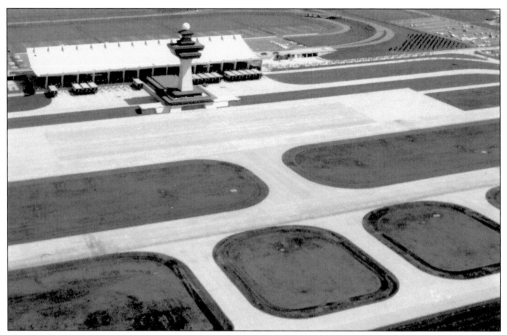

Shown here is an aerial view of the terminal with lounges in place on the apron area. This section between the building and holding area for airplanes was used by small private and commercial airplanes. In the upper right can be seen the Page Airways section, where later all private airplanes left and returned. (PC.)

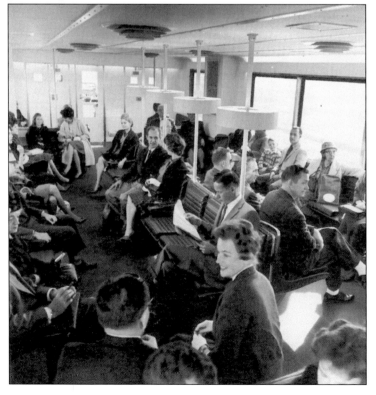

Here passengers are seated in a mobile lounge on their way to an airplane. The vehicle could seat about 90 people in a comfortable manner. There were no rules, directions, or qualifications for the drivers of these machines, so that was one of the first items to cover. One driver said it was like sitting on your front porch and driving your house down the road. (PC.)

Lights cast a shining glow from the interior. Each building responds in a different way, as do the base of the tower, the ceiling of the terminal, and geometric designs on the roof. There is something almost magical in the many designs. In the terminal, there are approximately 1,000 panes of glass, some 18 feet long. When nearly all the glass was in place, the lights were turned on one evening, and many people turned out to see the result. (MWAA.)

When designing the terminal for Dulles Airport, Eero Saarinen gave thought to the many people who would use the different facilities and their needs. A place to rest and eat was most important as were shops to purchase a last-minute item or a newspaper. Here travelers and locals take a time for a bite to eat. (MWAA.)

In the early days of Dulles, the travelers were fairly few, and the space between the counters and the exterior wall was wide open. One and all had the privilege of going about as they desired. When Pres. John F. Kennedy died, locals went to the airport and watched the world leaders come through the lobby. Close up watching for everyone, some saw Prince Phillip—a favorite—walk out, as well as many others. (MWAA.)

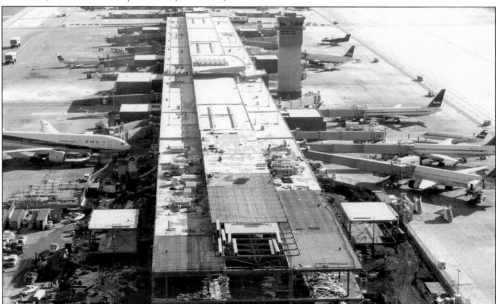

An aerial view of the midfield terminal shows a great deal of action. Airplanes load and unload, while construction work takes place on the lower section of the photograph. Continued growth made movement beyond the main terminal necessary. In the first year, there were 600,000 passengers, and in 2000 there were 20 million. The airport was known as Chantilly Airport during construction and until just before the dedication when it was named Dulles Airport. In 1986, it was named Dulles International Airport, and now it is Washington Dulles International Airport. (MWAA.)

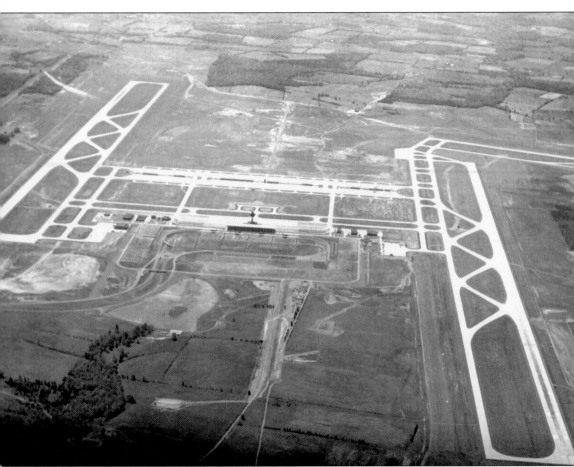

This photograph of Dulles gives a wide-open view looking south toward Chantilly. When the terminal was nearing completion, several wanted to be the first to land here, and it was said FAA chief Elwood R Quesada had planned a gala first landing; however, airport contractor C. J. Langenfelder made the first landing in his DC-3. While construction was going on, G. Ward Hobbs, director of National Capital Airports, said the airport would not be finished for 25 years and maybe not then. Someone else stated that we might handle rockets at Dulles in time to come. On the first day, there were 50 takeoffs and landings. The number of flights in and out continues to grow as has cargo space. Today cargo buildings provide over 54,000 square feet of operational space. Dulles is one of the busiest airports in the world, and it is twice the size of Idlewild Airport in New York. (MWAA.)

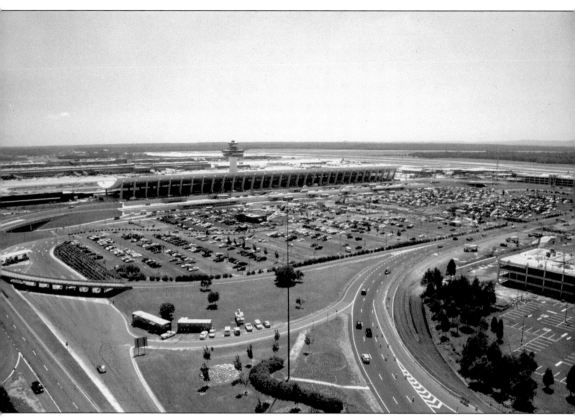

Today the terminal has been made twice as large as it was in its original design due to increased use and because making a larger building was part of Eero Saarinen's original plan. A section was added on to each end of the building, and it is now enormous. The funny-looking lounge, earlier known as the largest passenger carrier ever built on wheels, is still being used; however, there are many new and exciting things taking place that will further update the airport. One noticeable item at the site is a 330-foot tower so an even better eye can be kept on all that goes on. Because new and updated equipment will be installed, security will be much improved at the airport. (MWAA.)

*Five*

# DEDICATION DAY

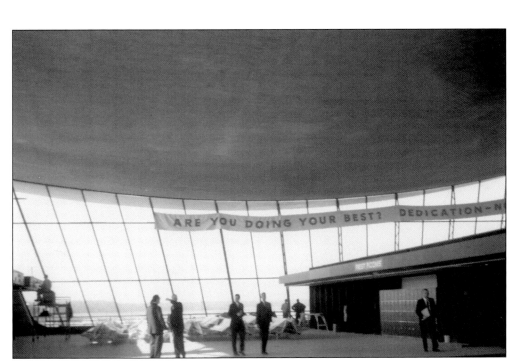

On November 15 and 16, 1962, an interesting tour was given at the nearly completed airport project. This special tour covered the airport in general, the control tour, and a ride on the mobile lounge. Invitations went out to former land owners and others to give them a first look at the new "Jet Airport." Much activity was taking place and many employees were busy going in different directions. The large banner shown in this photograph was in place across the windows, and the question of the day was "Are you doing your best?" (PC.)

The morning of the big day was fair but later became gray and chilly. Pictured here is the road leading into the terminal, while in the background approaching automobiles can be seen as well as the parking area beyond. This photograph shows how wide open the space was compared to today, now that so many additional roads, parking lots, and structures have been put in place. (PC.)

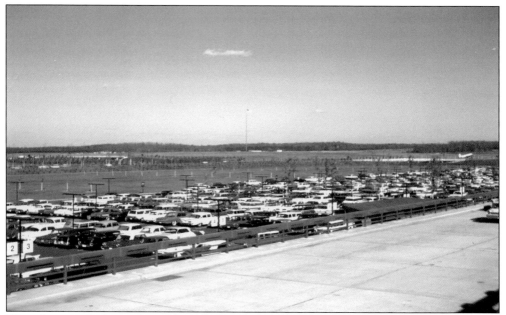

This photograph shows the parking lot on the north side of the terminal on opening day. The attendance was about 60,000. The front portion of the photograph shows the area by the main entrance with the lower or ground lot to the left. In early days, this upper space was used as general parking. For one quarter, visitors could park for an hour; for $1 they got four hours. (MK.)

*The Administrator of the Federal Aviation Agency*
*requests the honor of your presence*
*at the ceremonies in which*
*The President of the United States*
*will dedicate the*
*Dulles International Airport*
*at eleven o'clock on the morning of*
*Saturday, November seventeenth, nineteen hundred sixty-two*
*Chantilly, Virginia*
*Please present this card*

This is the invitation sent to former owners of land taken for the airport and to many thousands of others. On opening day, a sizeable collection of people gathered, from former-president Dwight D. Eisenhower to Pres. John F. Kennedy, national and local dignitaries, political representatives, airport workers, and plain citizens. Some people enjoyed two days of airport looking; they attended one of the preview days on November 15 and 16 and then again on November 17 or 18. Airplanes from various airlines, fire equipment, and other objects were on exhibit, giving the visitors an opportunity to see what would be arriving and leaving Dulles in the days to come. Although not as many people were in attendance as had been planned, those attending enjoyed their day of activities from speeches and military band music to tours and the Thunderbirds. It was a well-planned event and a great way to say "we have arrived!" (PC.)

# DEDICATION CEREMONIES

### Saturday, November 17, 1962

8:00 a.m.—Airport Opens

10:30 a.m.—U.S. Air Force Bagpipe Band
    Tech. Sgt. Melvin Ross, Pipe Major

10:45 a.m.—U.S. Army Band
    Lt. Col. Hugh Curry, Conductor

11:00 a.m.—Touch-down of Presidential helicopters

11:09 a.m.—U.S. Army Band Herald Trumpets
    Capt. Gilbert Mitchell, Conductor

11:10 a.m.—Introduction, G. Ward Hobbs
    Director, Bureau of National Capital Airports

Invocation, The Reverend Frederick Brown Harris
    Chaplain, U.S. Senate

Remarks, N. E. Halaby
    Administrator, Federal Aviation Agency

Remarks, The Honorable Dwight D. Eisenhower
    Former President of the United States

Remarks, The Honorable John F. Kennedy
    President of the United States

The National Anthem, U.S. Army Band

11:35 a.m.—Terminal building, mobile lounges and aircraft
    open for public inspection

12:00 noon—Flyover and Acrobatic Display,
    U.S. Air Force Thunderbirds—Runway #1

4:30 p.m.—Airport Closes

### Sunday, November 18, 1962

12:00 noon—Airport Opens

Noon-4:30 p.m.—Terminal building, mobile lounges and
    aircraft open for public inspection

1:00 p.m.—U.S. Navy Band
    Lt. Anthony Mitchell, Conductor

2:30 p.m.—Flyover and Acrobatic Display,
    U.S. Air Force Thunderbirds—Runway #1

4:30 p.m.—Airport Closes

This photograph shows the program for the dedication ceremonies at Dulles on Saturday, November 17 and then continued on Sunday, November 18, from 12 noon until 4:30 p.m. Again the terminal building, mobile lounges, and aircraft were open for public inspection. The U.S. Navy Band and the U.S. Air Force Thunderbirds also gave another performance. (PC.)

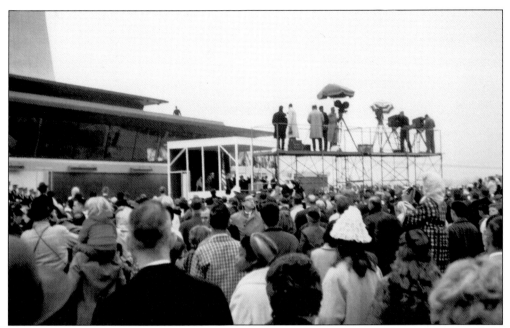

This photograph was taken just before the program began. The white platform was the speakers' area, while the platform with people standing on it was for reporters and photographers. With former-president Dwight D. Eisenhower and Pres. John F. Kennedy was Mrs. John Foster Dulles, widow of the late John Foster Dulles, Eisenhower's secretary of state for whom the airport had been named. On the balcony, a lone security figure can be seen. (MK.)

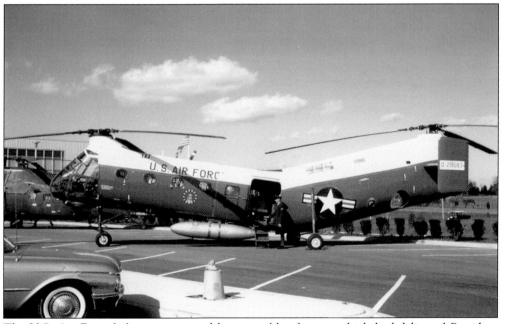

The U.S. Air Force helicopter pictured here was like the one which had delivered President Kennedy from the White House to Dulles Airport. In his speech, Kennedy made a remark about the fast journey from the White House to Dulles Airport; even so, he was a few minutes late with Eisenhower a little more so. (MK.)

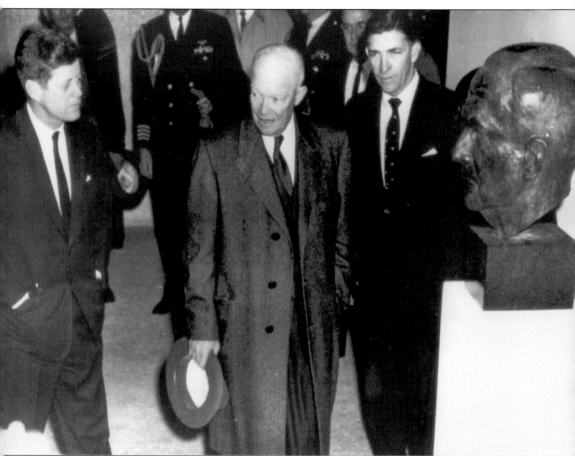

This photograph was taken as Pres. John F. Kennedy and former-president Dwight D. Eisenhower were walking through a portion of Dulles Airport on November 17, 1962, the big dedication day. Mrs. John Foster Dulles, wife of the late John Foster Dulles, who served as secretary of state for Eisenhower, and Najeeb Halaby, administrator of the Federal Aviation Agency, were also in the group. On the right of the photograph is a bust of John Foster Dulles created by Boris Lovetlorski, which was placed at the time by the reflecting pool in the terminal. Najeeb Halaby was master of ceremonies for the dedication, and in his brief words, he paid tribute to the architect, the planners, and especially the workmen who put in 12 hour days seven days a week in order to get the airport in shape for the event. The building, though not entirely completed, gave one the sense of how it would operate. (MWAA.)

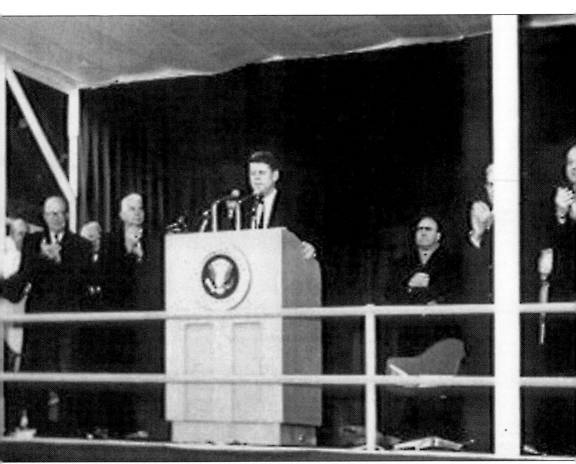

Pres. John F. Kennedy and former-president. Dwight D. Eisenhower each spoke at the dedication day program, and each had high praise for all who had played a part in the building of Dulles. Pres. John F. Kennedy speaks here to the large audience attending the opening. Kennedy expressed his pride in the contribution made by public and private citizens in constructing the terminal building. He extended compliments to former-president Eisenhower and Gen. Quesada for having the ability to realize that a jet airport was right for the Washington area. He thought the building was a symbol of aspirations of the United States in the 1950s and 1960s. Kennedy thought it appropriate to honor John Foster Dulles by naming the airport after him and reminded people that Dulles and other members of his family had served with distinguished and dedicated service. He ended the speech by saying "this is a great airport at a great time in the life of our country." (MWAA.)

The apron area on the south side of the terminal was a parking lot for different types of airplanes. There were individuals who gave an explanation of the aircraft, and visitors were allowed to board some of the planes. In the far back center can be seen the fuel tanks on Sully Road. The above photograph was taken from the west side of the terminal and tower. (MK.)

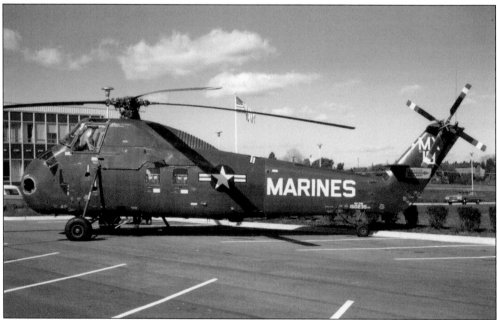

This photograph seems to say the Marines have landed, so all is in good hands. This piece of military transportation was impressive, and this was first-time, close-up view for many in attendance. Due to the manner in which helicopters take off and land, there is included in the ground plan at Dulles a special landing pad used only by helicopters. That is one of many safety factors in place at the airport. (MK.)

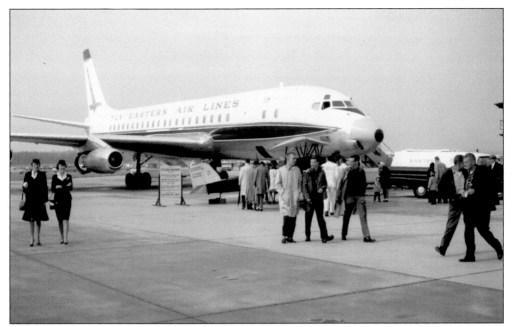

Eastern Air Lines has a plane front and center for the visitors to look at, board, and learn facts about airplanes, airports, and travel. Two of their employees are seen on the left dressed in the uniforms of the day. Children had fun pretending they were boarding and ready for take off to someplace special. (MK.)

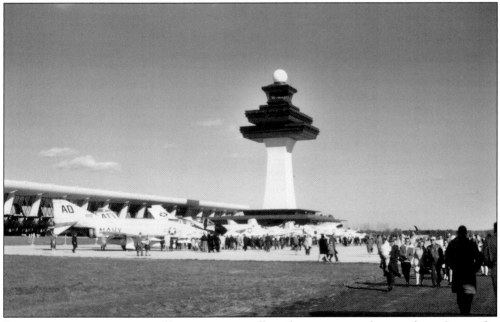

Runways, taxi strips, or turnoffs, visitors were allowed to go any and everywhere. It was the general public's day, and a sincere effort had been made to give them a day to remember. It would no doubt pay off, because many had not been too happy with the idea of having an airport as a neighbor. The majority of those attending were happy with what was seen and were looking forward to watching airplanes. (MK.)

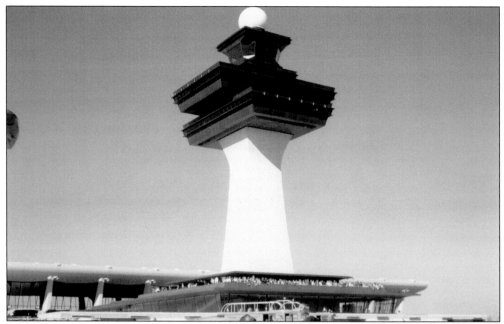

For the best view of everything taking place, the balcony was the place to be. One could mingle and visit or look below to exhibits placed around different areas on the grounds. Some activities were on the south side of the tower, which allowed those in the Portals Restaurant area or on the ground to observe the activities. (MK.)

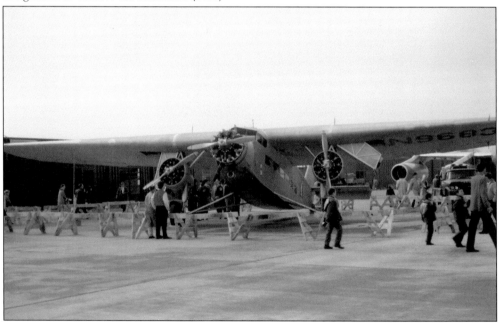

The airplane shown here is a Ford Trimotor, first produced in the 1920s. Sometimes this airplane was referred to as the "Tin Goose" or "The Junker," so named due to some of its material and the man who worked with the material on the airplane. The airport day gave one the opportunity not only to view airplanes but to talk with individuals who had new information to share with others. (MK.)

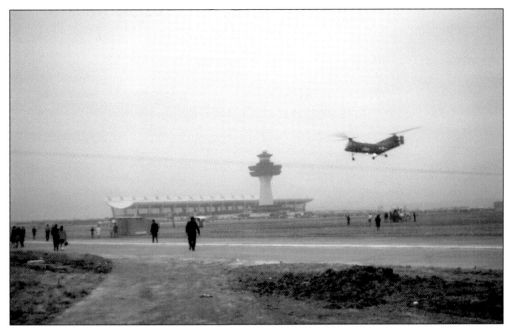

There is such a vast space around the new and beautiful building that the terminal appears to be an island with a sea of ground surrounding it. A troop-carrier helicopter has just taken off to return to base or carry passengers to a destination elsewhere. Years later, it is hard to think that there was so little on the 10,000 acres, as today it is filled with a variety of buildings. (MK.)

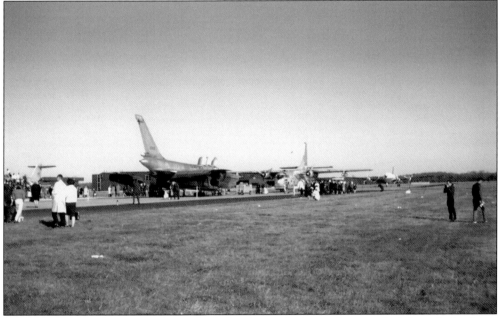

This scene took place near the end of the day with just a few people left to look about. Although there was a line at one airplane, the crowd had pretty much dispersed; perhaps some will return tomorrow. The next assignment was to those who would clean up the grounds for a new beginning on Sunday. The two days of airport activities were well received by the visitors. (MK.)

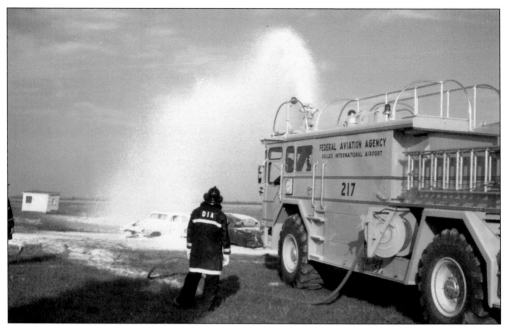

Dulles Airport has its own fire station, men, and equipment. Here a practice demonstration is taking place to show the effect of foam on a fire of the type which might take place at an airport. There have been no major accidents at Dulles, but a few situations have taken place. The most modern and up-to-date equipment is available for this airport, and if needed, it is shared with the area. (MK.)

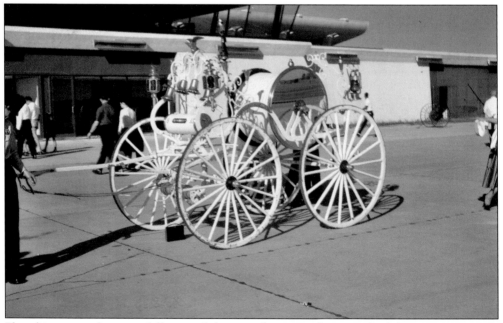

Placed in among the many different exhibits was this piece of antique firefighting equipment. It appears to be more of a parade piece than something of use during a serious fire, so one can only wonder just what use it was in a serious situation. This may have been on loan from a collector or the Smithsonian Institution for the dedication event at Dulles. (MK.)

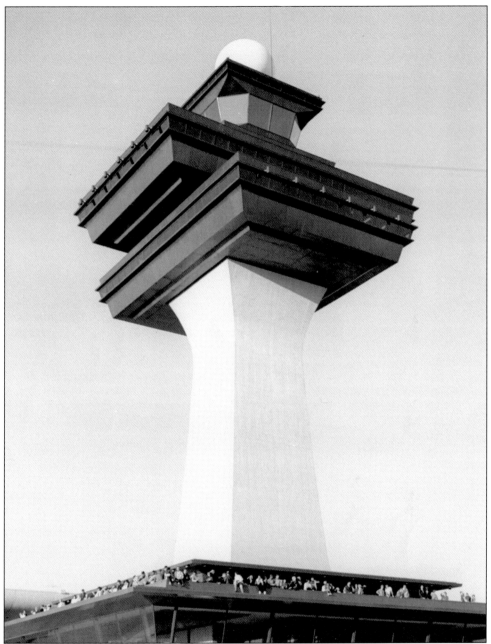

It is thought this photograph may have been taken on dedication day after President Kennedy and former-president Eisenhower had left the event. The tower was an interesting piece of architecture designed by a man who thought beyond ordinary things and enjoyed having his work make a statement. The tower was to house many different activities, from a restaurant where one could eat and watch the aircraft come and go to the radar equipment placed in a topmost position. From the top observation room, workers could observe all that was taking place on the grounds. They could see every inch of the runways and beyond to the trees surrounding the acreage. People standing out in the open on the visitor's balcony of the tower were often surprised to see deer and fox out on the open area. (SF.)

On April 20, 2002, a marker was placed at the airport by the Daughters of the American Revolution. Mary Browne, regent for the Cameron Parish chapter, was in charge; Elizabeth O. Haugh, vice president general, extended greetings, and Keith Meurlin, vice president/manager of Washington Dulles International Airport, gave a talk. Francis Lightfoot Lee, a signer of the Declaration of Independence, once owned some of the airport acreage. Mary Browne is shown with Charles Waddell, former state senator. (MB.)

The Reverend Richard E. Fichter Jr. delivered the benediction for the occasion, and the program then ended with the singing of "America the Beautiful." Reverend Fichter serves at Grace Episcopal Church in Kilmarnock, Virginia, but his grandfather, Rev. Lloyd Bell, was at Saint Timothy's Episcopal Church in Herndon in the 1960s. Richard is shown here with his mother, Suzanne Bell Fichter. (SBF.)

*Six*

# A House Saved
# and R. E. Wagstaff

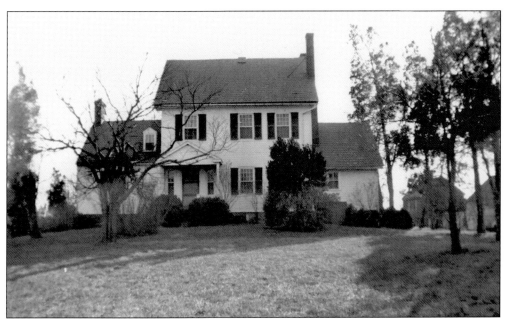

This photograph of Sully Plantation's house was taken in 1958, when decisions were being made regarding a jet airport at Chantilly. The main section of the house, built in 1794, with a wing added in 1799, was constructed with beaded clapboard siding over brick nogging. The house, served by a double chimney on the west side and a single chimney on the addition, was heated by seven fireplaces. This building plan is sometimes found on the Northern Neck of Virginia. (SF.)

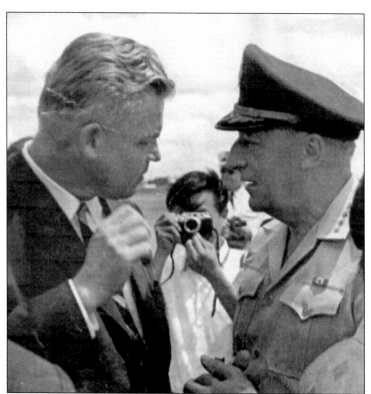

Frederick and Lindsay Nolting, along with their daughters Molly, Lindsay, and Frances, moved from nearby Vienna to Sully in 1946. Daughter Jane was born several years after their move to Chantilly. The Noltings had purchased the property from Walter Thruston and his mother, Beatrice Thurston, in April 1946. Ambassador Nolting is pictured here many years later with Gen. Paul Harkins just before Nolting left South Vietnam to return to the United States. (PC.)

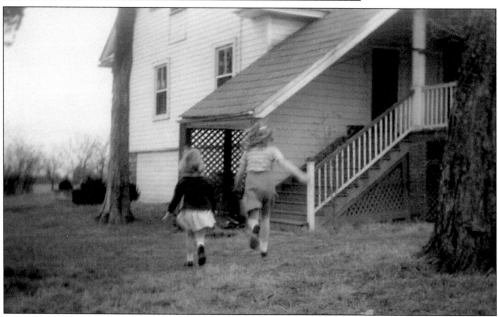

This is a photograph of two of the Nolting children running across the west lawn at Sully. The Nolting family settled at Sully in time for Molly to begin the first grade in September 1946. The girls and their parents enjoyed their new home, which had started as a plantation, moved on to dairy farm status, and was now considered a country estate. The family lived at Sully until Nolting's assignment with NATO necessitated a move to Paris. (SF.)

After receiving notice of planned land acquisition by the federal government, Frederick Nolting went by to talk to R. E. (Eddie) Wagstaff regarding what was about to take place in the area. The end result of their meeting was that Wagstaff took his toothbrush and moved into Sully. The house would benefit from his being there since much pilfering was taking place at any property left vacant. Shown here is the note Nolting sent just before returning to Paris. Later in his work at the U.S. State Department, Frederick Nolting was given an assignment as ambassador to South Vietnam. (SF.)

Mon. Mar. 3, 1958

Dear Mr. Wagstaff,

I hope your stay at Sully will be a happy one, and that one of these days we will be back too for a visit. Thank you for being willing to help us and Sully.

I have not seen Jake again, but it was definite that he would keep the grass cut, etc., and would move into the stone house sometime this spring. You will want to confirm this when you see him.

I leave this house with a heavy heart.

Yours,

*Fritz Nolting*

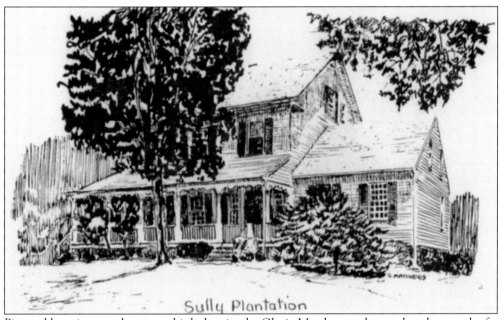

Sully Plantation

Pictured here is an early pen-and-ink drawing by Gloria Matthews, who produced art work of a number of Fairfax County historic sites. The house at Sully Plantation has an appeal to many, for it is a house that appears to be at home in its setting. Through the years, visitors often stated "it is a house anyone could move into." Fairfax County is fortunate to have had Eddie Wagstaff and other individuals interested in keeping it safe. (SF.)

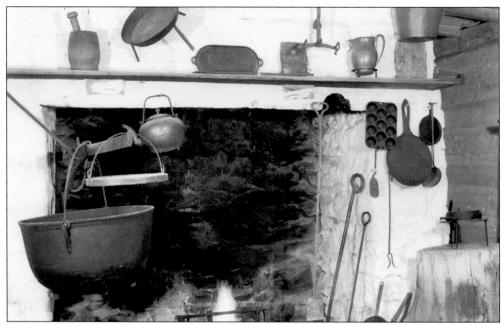

This photograph shows the kitchen at Sully in the early days of being open to visitors. Early on, the staff cooked "hoe cakes" over the open fire—not so good to eat, but interesting to talk about. Later a variety of kitchen-related programs were presented to visitors, ranging from simple "how to" demonstrations to a complete meal cooked over the open fire. (SF.)

Fred. M. Packard, the first director of the Fairfax County Park Authority (1959–1962), is pictured here with a park friend. When approached regarding Sully, Packard was interested and thought it possible for the park authority to be involved, for he understood the importance of Sully and the need to keep the buildings from being destroyed. Until this time, the Fairfax County Park Authority (FCPA) had worked in the direction of nature and natural parks, not historic structures. (JP.)

# Calendar No. 726

<table>
<tr><td>86TH CONGRESS<br>1st Session</td><td>SENATE</td><td>REPORT<br>No. 721</td></tr>
</table>

## PRESERVATION OF HISTORICAL SULLY BUILDINGS, CHANTILLY, FAIRFAX COUNTY, VA.

AUGUST 13 (legislative day, AUGUST 12), 1959.—Ordered to be printed

Mr. MAGNUSON, from the Committee on Interstate and Foreign Commerce, submitted the following

## REPORT

[To accompany H.R. 4329]

The Committee on Interstate and Foreign Commerce, to whom was referred the bill (H.R. 4329) to provide for the conveyance to any public or private organization of the State of Virginia of certain dwellings acquired in connection with the Chantilly Airport site, Virginia, and for other purposes, having considered the same, report favorably thereon without amendment and recommend that the bill do pass.

### PURPOSE OF THE LEGISLATION

The purpose of this bill is to preserve the historic Sully Mansion buildings near Chantilly, Fairfax County, Va., on property now being developed for a second Washington airport.

The bill would authorize the Administrator of the Federal Aviation Agency to convey to any public or private organization of the State of Virginia, without cost to the Federal Government, title to the buildings and to grant an easement for use of land necessary for maintenance and use of such buildings for historic purposes, with certain limitations set out in the legislation.

Furthermore, the legislation would permit the dismantling of the Leeton Mansion buildings on the airport site, and the salvaging and removal of materials of historic value.

### ANALYSIS OF LEGISLATION

Paragraph (a) of the bill would authorize the Federal Aviation Agency to convey title to the Sully Plantation buildings to any public or private agency of the State of Virginia, without cost to the Federal Government, and to grant an easement for use of such land as

34006

---

This is the front page of Calendar No. 726, which contains Senate Report No. 721 (to accompany H. R. 4329) regarding saving Sully Plantation and permitting the dismantling of the house known as Leeton. Contained therein are letters from Fred M. Packard, director of parks; Phillips S. Hughes, assistant director for legislative reference; and E. R. Quesada, administrator. Rep. Joel T. Broyhill worked to save Sully and tried to keep the name of the airport as Chantilly. (SF.)

Eddie Wagstaff stands in the entrance hall at Sully in his favorite place and position, talking with visitors. Eddie Wagstaff called the Chantilly/Herndon community his home, living first at Leeton then after 1941 at a new home on Barnsfield Road or in Herndon. His interest in history was immense, and when it appeared Sully might be destroyed, he began to campaign. He was joined by Eleanor Lee Templeman, a Lee descendant, and many people from the surrounding communities. (SF.)

Eleanor Lee Templeman, a great grand-daughter of Richard Bland Lee, the builder of Sully, was a fellow worker for Sully's fight. She worked with Rep. Joel Broyhill, the Society of Lees, Eddie Wagstaff, and others who were interested in seeing the house saved. Lee descendents are extremely proud of their place in Virginia history. Pictured here is a copy of the Lee family coat of arms. A copy done by Thom Hanes can be seen at Sully. (SF.)

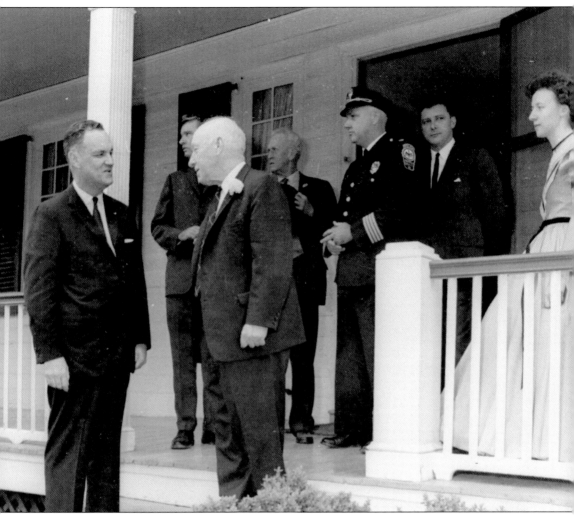

Gov. Mills Godwin visited Sully Plantation on April 26, 1966. Shown on the porch with Governor Godwin and Eddie Wagstaff are members of Godwin's staff and Ilene Baxter of Herndon. Ilene was one of the high-school-student guides at Sully who were members of a Herndon Girl Scout Troop. Millicent Stutzman of Herndon, as scout leader for this group of girls, trained them for their involvement with tours and visitors. Eddie Wagstaff kept in touch with individuals on both the county and state level who might assist with his ongoing campaign for Sully; therefore no one was surprised when Governor Godwin was able to make a visit to Sully. Eddie Wagstaff was always aware of what was taking place, not only in Northern Virginia but also in Richmond. In addition, he enjoyed visiting and sharing information with friends in the community. (SF.)

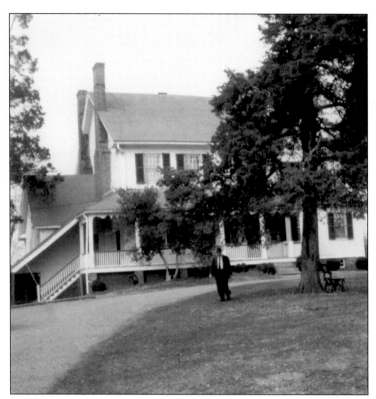

Here Eddie Wagstaff walks across the south lawn at Sully Plantation elated no doubt because his effort has paid off and the house was not taken down. Eddie Wagstaff remained at Sully and later became a member of the Fairfax County Park Authority (FCPA) Board. He stated he desired no pay as a board member but wanted the funds to go toward the upkeep of Sully. (SF.)

Programs for Sully were started soon after the site's opening, and in May 1965, the first Sully Days was held. Pictured here is Doris Heath explaining to visitors how wool and cotton can become yarn and thread. In addition, at another station, a weaver used a large loom to give the visitors a demonstration of the thread being woven into fabric. These were two of the many crafts shown to the public at Sully's events early on and today. (SF.)

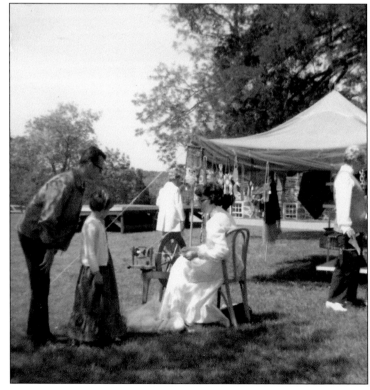

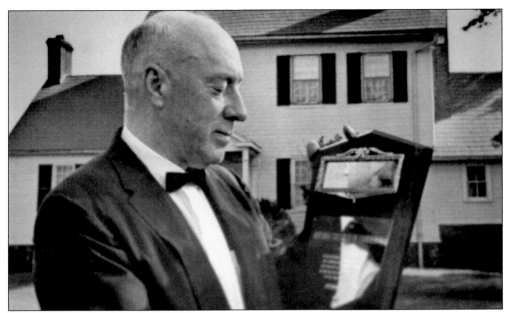

The Herndon Chamber of Commerce presented Eddie Wagstaff with a plaque for his work in saving the historic site. He is shown standing on the north lawn, the formal side of the house. Wagstaff served as the first curator for the property and devoted the rest of his life to this project. In 1969, he set forth a foundation to assist with the site then set $250,000 aside to fund this project. (SF.)

Sully was always an interesting and fun place. The staff members, both full-time and volunteer, worked well together covering the site and taking care of the many visitors. This photograph shows staff members in the basement office. They are, from left to right, Gayle Williams and Margaret Peck of Herndon, Minnie Blankenship of Fairfax, and Lynn Hastings of Reston, bent over working. Sully continues today under the direction of responsible and dedicated staff members. (PC.)

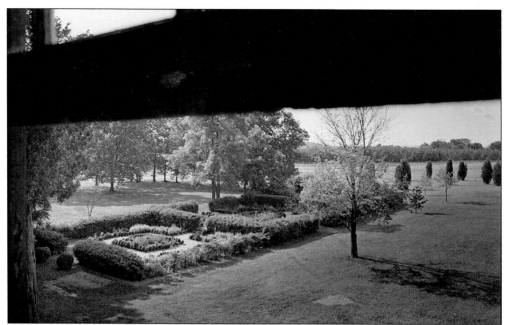

In the mid-1960s, the Fairfax Garden Club planned a formal garden at Sully. There was no evidence of a formal garden, but the garden was a welcome addition. The garden is seen here from Cornelia's room on the second floor. Cornelia Lee and her sister, Portia, often visited their relatives at Sully, so the room on the northwest corner of the house was named Cornelia's room. A new garden in a different location was planned and designed by the FCPA. (SF.)

Sully's first vegetable garden was started in the early 1970s and has continued on to the present time. Volunteers have been the main caretakers of this garden, and for several years, Virginia and Larry Clarity took over its care. Today the garden continues, with a variety of plants and seeds put in each year, to give a picture of what used to be grown in home gardens. (PC.)

Mr. and Mrs. Alex Haight, he a descendant of earlier owners, chat with Ben Peck while attending a reception to observe the release of the book *Sully—The Biography of a House* by Robert S. Gamble, a historian and author from Huntsville, Alabama. The book tells the story of Sully, a story which is a reflection of what was taking place elsewhere in Fairfax County. (PC.)

Staff member Constance Neville descends Sully's third-floor stairway in the 1970s. The house was filled with Christmas greens by the Mantua Garden Club of Fairfax, and a tree was decorated by fourth-grade students from Mosby Woods Elementary School. The tree decorations were based on Minnie Haight Middleton Ellmore's memories of visiting Sully at Christmas. Minnie Ellmore, as a child, lived across the fields at Leeton. The site hosts a variety of Christmas activities each year. (PC.)

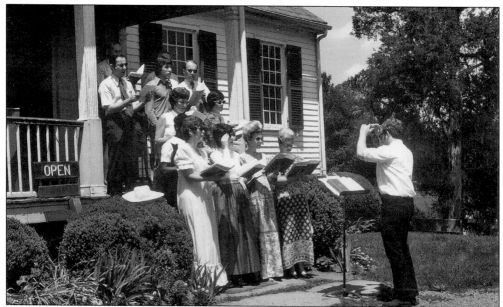

One of the groups that presented music programs at Sully on summer Sunday afternoons in the 1970s is pictured here. While the educational program has been taken to schools or shared with students on site, there are many special programs throughout the year. The two largest events are the Antique Auto Show in June and the Quilt Show in September. Depending on the subject of other programs, one will find history lessons of the 18th, 19th, or 20th centuries. (PC.)

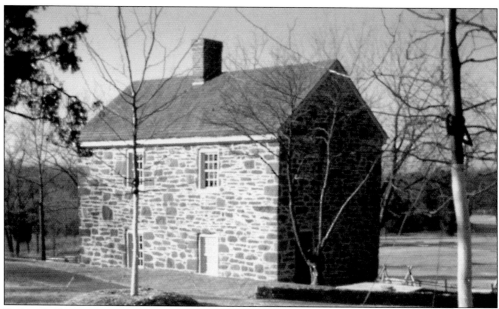

Before Sully was open to the public, Eddie Wagstaff went to classrooms to tell his story about Sully. He knew that a good way to interest adults was through the eyes of their children. The staff offers a site school program with learning centers using the stone house, the log house, and yard kitchen in addition to the main house. Pictured here is the stone house, where spinning and weaving demonstrations were given to the classes and at special events. (PC.)

When the Concorde made its first landing in Virginia, the staff at Sully was on hand to watch its arrival. In the excitement of that special day, an individual went to the house and knocked but received no answer. Before long, headquarters was called and a complaint made. Next came a call to the site to inform the staff. The words were not wanted, but who was going to miss being a part of such an event? (SF.)

In the early 1970s, the house was closed except for ground tours while restoration work on and in the main house took place. The needed repair work was taken care of, and changes were made, as new evidence unfolded. Here is a photograph of Sully taken after the restoration was completed. The house shows its south side, and the other structures seen are, from left to right, the stone house (dairy and later uses), smokehouse, and yard kitchen. (PC.)

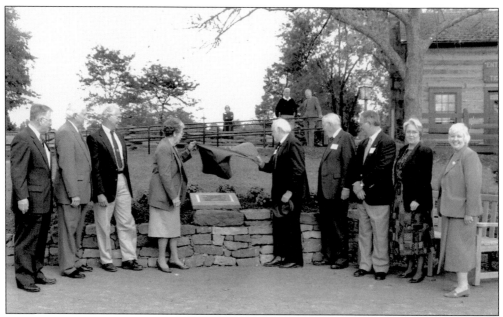

The FCPA presented a plaque to Sully Foundation's Board of Directors. From left to right are Thomas White, chairman, FCPA Board; Harold Strickland, member, FCPA Board; Lewis Leigh Jr., Sully Foundation; Margaret Peck, Sully Foundation; Mayo Stuntz, chairman, Sully Foundation; Karl Stutzman, Sully Foundation; Thom Hanes, Sully Foundation; Kate Hanley, chairman, Fairfax County Board of Supervisors; and Elizabeth David, Sully Foundation. (PC.)

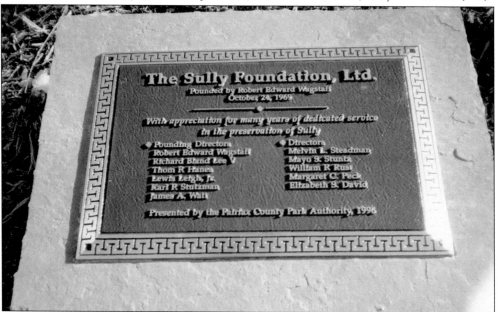

This is a photograph of the plaque the FCPA placed at Sully in 1996. The words state, "With appreciation for many years of dedicated service in the preservation of Sully." The Sully Foundation Board is comprised of eight members who are residents of the community or members of the Lee family. Wagstaff named the original group, and the active board names a replacement when needed. (PC.)

# *Seven*

# COMMUNITY CHANGES

Dulles opened in 1962 with great fanfare, and life continued on. Changes had begun in the area before the airport became a reality, but they hastened after its arrival. This photograph shows a view to the west from Floris Lane, the scene is rural except for an airplane heading for Dulles. (PC.)

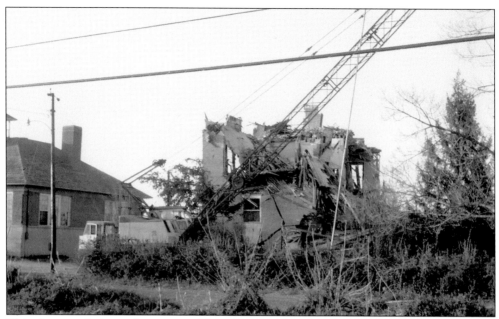

This photograph shows the one-time Floris Vocational High School, built in 1920, when it was being torn down about 1958. After a new school was constructed on Centreville Road in 1954–1955, this school property was acquired by the FCPA. The 1911 building to the left was saved and is in use today for Katydid classes and camps, the annual 4-H Fair, and other numerous Frying Pan Park activities. (PC.)

Everybody in the area knew Neal Bailey who lived on Coppermine Road with his wife, Cora, and other members of his family. Neal began working for the Ben Middleton family when just a boy and continued as long as the family farm was in operation. Land taken for the new airport did not include Neal's home, but in time, he sold as a result of the growth and development taking place in the area. (CL.)

Local families have made good use of Dulles Airport since it opened. It is much easier to drive three or four miles than to drive into Washington, D.C., to National Airport (now Ronald Reagan Washington National Airport). In 1965, Emily and Jermey Leigh stood for a photograph with Gesa Adam, a Penn State student, who was returning to Germany after a Herndon area visit. Before she left, they all enjoyed a visit to the observation tower to watch the airplanes. (CL.)

This is a photograph of the Activities/Equestrian Center at Frying Pan Park, which opened in 1980. It has been said that today there are more horses in Fairfax County than in the days when horses were providing the power for all farm work and transportation. Throughout the year, special events—horse shows, auctions, schools, and training—take place in this large building. In the winter and during inclement weather, the space is often used for soccer or other sports practice. (PC.)

One of the large dairy farms in the community had been owned by several generations of the Benjamin Middleton family since coming to Fairfax County in 1872. Today the large brick home and the collection of farm buildings, including the large-tile dairy barn, have all been removed from the scenery of the area. Now only the silo remains to indicate the site once told a different story. (PC.)

Smith, Middleton, Bradley, Armfield, McNair, Franklin, Harrison, Cockerill, Peck, Ellmore, and McLearen are among the names found in various locations today in the area south of Herndon. The names are attached to streets, parks, schools, home developments, and commercial property. Sometimes new residents are very surprised to find there was actually a family with the same name that their location carries. (PC.)

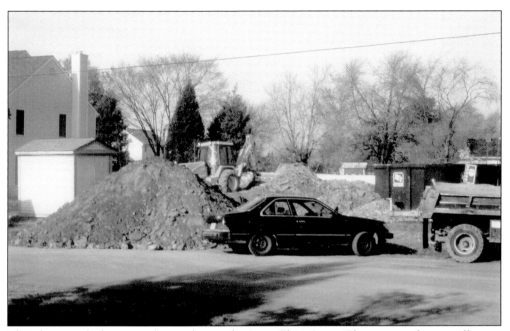

This photograph shows new home about to begin on Floris Lane. The owners of two small tracts of land pooled their holdings thereby providing space for a development of 42 homes. Families not only from the United States but also from several different countries decided to make their homes here thus creating an interesting international neighborhood. (PC.)

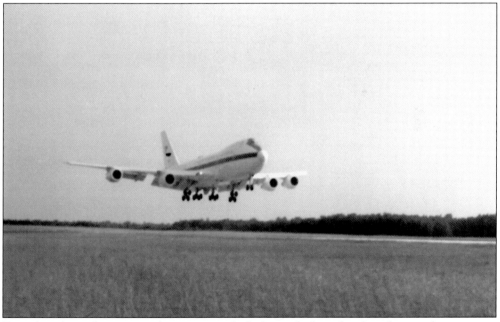

Even though residents stopped going out to look skyward when they heard an airplane go in or take off, one is still sometimes startled to see such large airplanes fly by. Now that the terminal has doubled in size, the view as one reaches the rise on the airport road is even more awesome to observe. One can only think that Eero Saarinen would be immensely pleased with the finished project. (ML.)

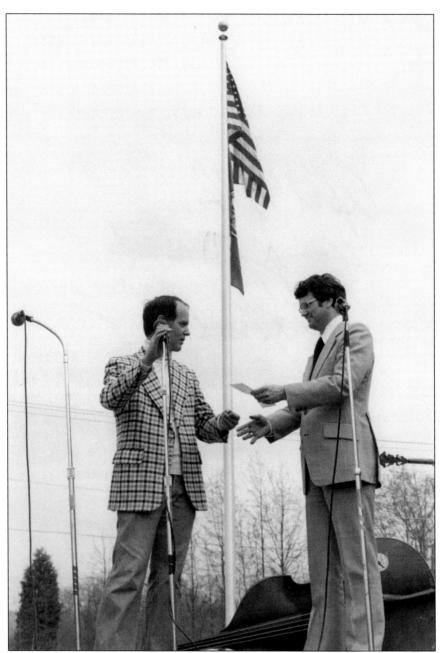

Citizen's National Bank was Herndon's bank for years and was "the bank" when the beginning activity for a new jet airport came to town. Local residents filled most positions from office staff to cashiers to president. In time, Citizen's became a part of Fidelity American Bankshares with other mergers taking place through the years. Thom Hanes made banking his career and became president of Fidelity American Bankshares when it merged with Citizens National Bank. Pictured here in 1976 when Fidelity American Bankshares opened, Thom Hanes, president (left), and Tom Rust, mayor of Herndon help with the celebration. Later Thom Hanes organized the Bank of the Potomac and served as its president. After several other mergers, Thom Hanes retired in 2001 having had a successful banking career in his hometown. (TH.)

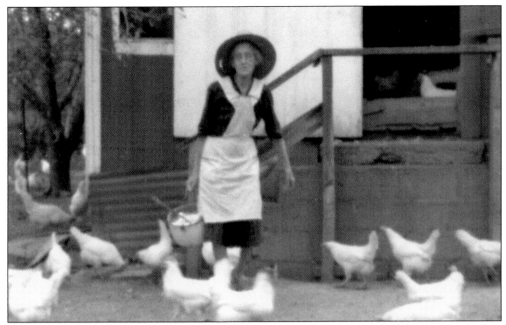

Sis (Edna) Middleton, like many, was not too happy when a majority of the home farm ended up being a part Dulles Airport; however, she did not make many changes to her pattern of life. She continued enjoying visitors, quilting and tatting, taking care of her poultry, and making cookies for visiting children, but she said she always turned her back on the airport when she worked in her garden. (CL.)

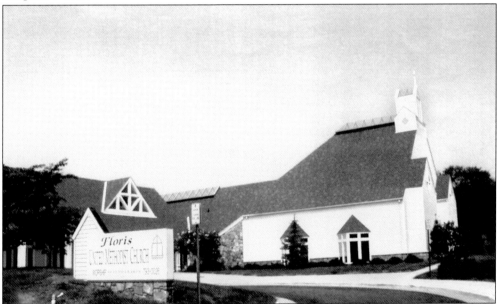

The Floris community grew and outgrew not only school space but also church space for some denominations. Since the Floris Methodist Church could no longer accommodate all interested individuals in the 1895 building, a new church was constructed nearby. The move in 1993 answered the then present need; however, it has not been long lasting. Space has again become a problem. (PC.)

This square and neat looking structure was the dairy building at Roscoe Crippen's Sugarland Dairy Farm. The entire farm was eventually turned into a development for many families moving to the Herndon area. (TH.)

With a church that has a Swedish look and a shopping center that is Bavarian in design, the Floris community is definitely changing its look. The facades of buildings may be different and different languages may be spoken, but basic needs are taken care of and residents are being given the opportunity to enter some different worlds, not just in the grocery store, but elsewhere in the community. (PC.)

The group shown here from left to right are Edith Nalls, Patsy Middleton, Clara Leigh, and Dan Nalls in attendance at the 1972 Transpo (an air show) held at Dulles Airport. Two different air shows or events were held at Sully a number of years ago, and in each, an individual was involved in an accident. Perhaps the days are too busy for such activities at the airport now. (CL.)

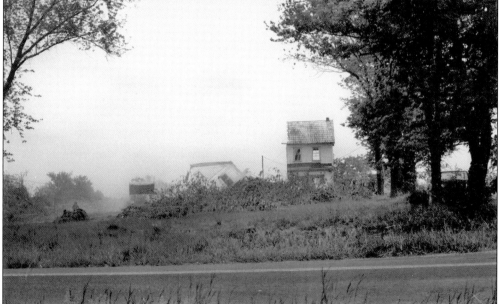

The Cockerill home on West Ox Road, which was built in 1896, had its time swept away by bulldozers early one morning. Several family members watched the building being pushed over, section by section while remembering some of the family's nearly 100-year history that went with it. Little by little, the community is moving in a different direction; hopes are it will remain community-oriented. (PC.)

Before long, the house and all debris had vanished, and houses began to be constructed where not too many years ago corn and hay had been growing. New families from many places picked out their floor plans and began the process of moving to a new home. The schools acquired new students and community churches welcomed the families at their services. (PC.)

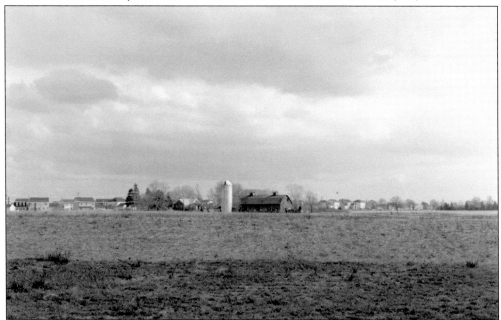

The vacant farm buildings stand lonely, as fields across the road fill with houses. The road from beyond Chantilly (Route 50) to Groff's Corner/Town Center (Route 7) was at one time bordered with dairy farms; now it is bordered by housing developments. This area in Virginia, which includes both Loudoun and Fairfax Counties, was well known for its part in agriculture in general and the dairy industry. (PC.)

104

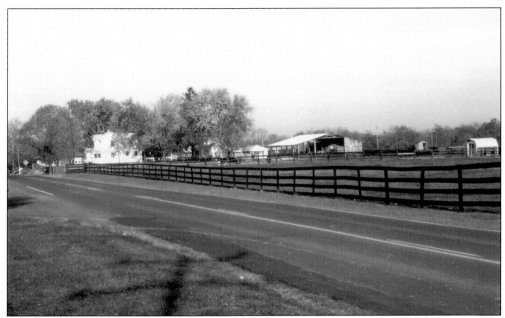

Shown here is a pastoral scene at Frying Pan Park, where animals graze in the pasture field. The park provides the community with open space that will always remain as such. There are horses, cows and calves, chickens, presidential turkeys and peacocks, field crops, gardens, and flower beds with each season bringing a special time. This park keeps a bit of the former community in reach for all who are interested. (PC.)

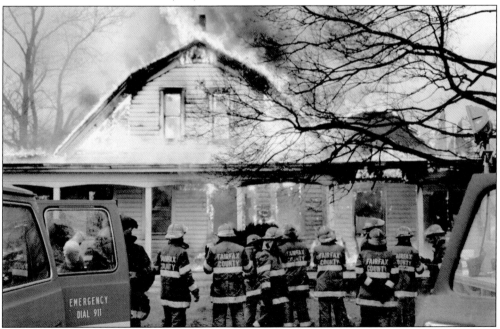

Built in 1913 for the Peck family, this was given up as a family home in 1968. After half of the farm became a part of Dulles Airport and rented land was sold, lack of acreage made the property no longer suitable as a dairy farm. As with many other buildings that were to be taken down, the Fairfax County Fire Services used the burning building as a practice session. (PC.)

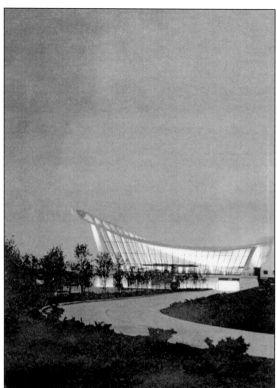

This photograph was also used as the cover scene for Images of America: *Washington Dulles International Airport.* Though most people think the terminal building is outstanding during the day, they can only think it is awesome at night when there is light on inside. When the electrical work was nearly completed, the decision was made to try out the lights. Those in charge were surprised how many workers stayed to see how the building looked when lit from within. (SF.)

The Concorde raised many questions when the announcement was made it would be flying into and out of Dulles Airport. Residents and officials questioned the positive and negative facts about the situation being created, damage to buildings, destroyed ozone, or a cause for hearing loss. None of the above happened, but Jean Packard, chairman of the board, and supervisor Martha Pennino both voiced their concerns. (PC.)

Ben Peck (top, left), Ben Bradley (top, right), and Austin Bradley (bottom) grew up in the Floris community, and each had a deep interest in aircraft and flying. All three men served in the armed services but at different times—World War II, the Korean War, and during peacetime. In addition, all were with airplanes while in service. Ben Bradley is shown here climbing into a T-2 Buckeye trainer; he also flew several other types of airplanes for the navy and Federal Express, including the DC-10, Airbus, MD-11, and Falcon. Austin Bradley flew 727s from Dulles to Dallas–Ft. Worth often and also flew the DC-10 from Dulles to Los Angeles. Ben Peck had a Cessna 150, and his best story is when Air Force One's back-up plane had to wait behind him at Dulles because he had already been given clearance to land. All three men are still interested in flying and aircraft. (PC, A/BB.)

Two not so ordinary airplanes are parked on the south side of the terminal at Dulles Airport. The airplanes, a British Airways Concorde on the left and an Air France Concorde on the right, always drew attention. Seated or standing on the tower balcony is a large crowd of visitors, while others move about around the airplanes. The airlines flew their aircraft in and out of Dulles, and many delighted in seeing them, even though their sound was a bit loud. An Air France Concorde arrived on June 12, 2003, for delivery to the National Air and Space Museum, and it can be seen today as one of the two most popular items at the Udvar-Hazy Museum. On October 14, 2003, the British Airways Concorde paid a farewell visit to Dulles Airport, and a number of residents went over to see the landing. (SF.)

# *Eight*

# MOVING ON

Locals knew their lives would have to adjust with the arrival of Dulles but perhaps not quite how much, and they also felt some situations would remain the same. Balch Library in Leesburg and the Virginia Room in Fairfax have been the place to go for research about the past, and that will remain the same. Now some of the history which has been and will continue to be created about Dulles will be found within their walls in various types of records. Balch has a new addition, and the Virginia Room will go through some changes to provide space for new materials. (PC.)

Janelia Farm often made one wonder about the house behind the trees since only the large chimneys could be seen from Route 7. Many knew Mrs. Pickens was an artist and that the acreage had at one time been a farm. Today there are some new buildings on the property, and much activity takes place at the Howard Hughes Medical Institute being established there. The house is now being given a new look in step with the other changes. (PC.)

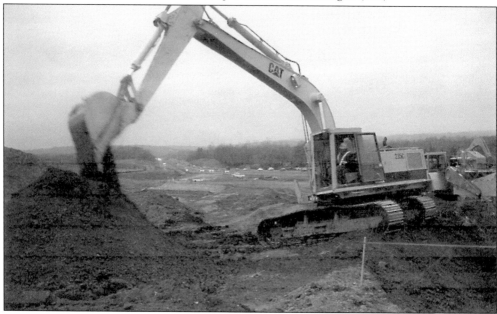

In the beginning—after much talk about Routes A and B—a road was constructed from the McLean area to Dulles. This road did not solve all needs, so additional lanes were set up to function as a toll road. The toll road has been extended to Leesburg, is referred to as the Dulles Greenway, and was funded with private money. Pictured here, a Caterpillar 375 hydraulic excavator digs in a ditch during the building of the Dulles Greenway. (PC.)

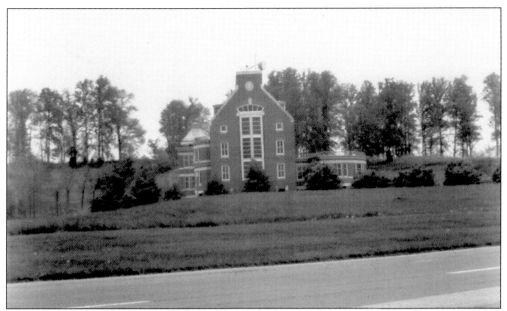

George Washington University's main campus remains in the city, but a portion has moved to the suburbs, making classes available to additional students. The University Center has been established on land that early newcomer Marcus Bles purchased after selling his Tyson's Corner property for some of the various commercial ventures there. The Bles home, now gone, was on the ridge behind the large brick building. (PC.)

College is not for everyone, and not every college has to be a four-year school. The building of Northern Virginia Community College, or NOVA as the school is often called, is a splendid answer. Many are able to further their education closer to home and for a smaller cost. A new building at the Loudoun campus has been named for Charles Waddell due to his interest and help through the years he served in Richmond. (PC.)

Reston had its beginning, along with Dulles and Sterling Park, in the 1960s. A population of about 75,000 was expected when the village was built out, and it appears to be headed in that direction. Reston offers residents good restaurants, outstanding health facilities, along with several shopping areas and recreational choices, including ice skating in the winter and concerts in the summer. Shown here is Reston Hospital Center. (PC.)

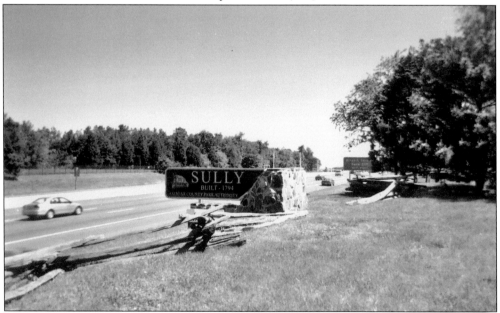

There is a new sign at Sully, and another important sign will soon be in place. When the interchange is completed for the Udvar-Hazy Museum, the eastern portion will head for Sully. The new road to the plantation house will follow the direction of a past road, and plans are being made for new structures on the grounds in the future. The two museums provide an opportunity to learn about the old and the new in one trip. (PC.)

Traditional and Colonial single-family homes and high-rise apartments are offered to families wanting to relocate from elsewhere or who just want a change. Those who pick Reston as a new location will have an opportunity to view many types of housing before making a decision. Pictured here is a building in Reston that offers a variety of living selections. (PC.)

A special treat when visiting the Udvar-Hazy Museum is the trip to the observation tower. This photograph shows what a view is in place on a clear day. Beyond the sky of beautiful clouds can be found some of today's landmarks. Off in a distance are the Worldgate Hotel, Herndon's water tower, and office buildings off Coppermine Road. (PC.)

Sterling Park, Loudoun County's first large development, was started in May 1962. The project planned for 3,500 houses and 3,000 apartments for 22,000 to 30,000 people, according to the *Washington Star*. Some of the land was acreage owned by the Bridges/Hummer family; the Hummers are descendants of William Hummer, who served in 1776. Today some of his descendants live in Sterling, close to what was the family farm. This photograph shows Peggy and Bill Hummer's home in Sterling Park. (WH.)

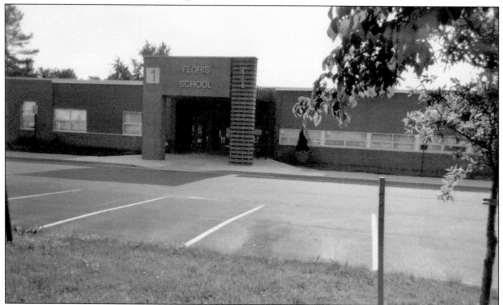

The first Floris School was constructed in 1876; the present one dates from the mid-1950s and is located about one-half mile from the earlier site. In the 1950s, approximately 300 students attended Floris; today there are three times that many. In 2004, after 50 years use, the school building received a fine makeover: space inside was changed and rearranged, while the façade of the building was improved. A new sign will correct the date of the first school. (PC.)

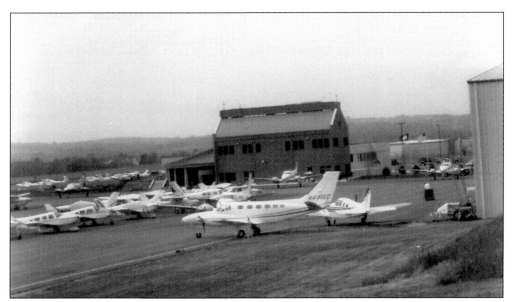

The Leesburg Airport has grown in recent years just as the town has grown. There are still individuals taking lessons and renting airplanes, a greater number of private jets coming and going, and people driving out to watch. The new administration building is named for Stanley Caulkins, a longtime Leesburg resident who has always had an interest in aviation. He was one of the town representatives who worked with Authur Godfrey to move the airport to Sycolin Road. (PC.)

By 1957, the Willis Williams family was settled in at their Sterling location. Their greenhouse grew wonderful plants. For years, the Williamses have furnished some of the vegetable and flower plants for local gardens, while local churches along with the National Cathedral in Washington, D.C., have depended on them for special plants at Easter and Christmas. Shown here are containers filled with excellent bedding plants in a greenhouse at their place. (PC.)

A barn on West Ox Road at the former Ellmore-Smith farm was used as a church for over 10 years. The cow stalls and feeding area were torn out, and different flooring was put down. The walls were given a new look, and an addition was built on the south side. Painted barn red with white trim, it provided a homey place for services. Today the inside has again been updated, and the property is now part of Frying Pan Park. (PC.)

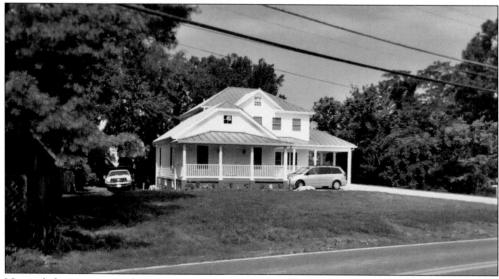

Not only have new townhouses gone up, but some families enjoy recreating a home with a past. Here an interwar-era bungalow has emerged as a much larger home to fit a family's needs or today's market. Herndon has homes dating from the 18th century and all periods since. One can easily find a place to fit into small-town living. (PC.)

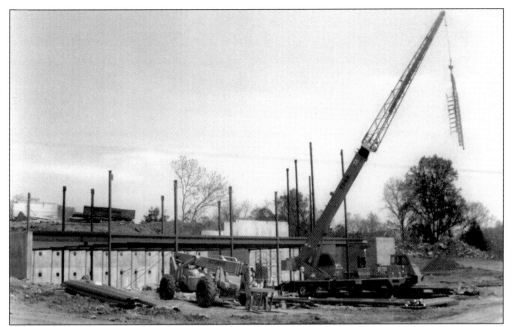

Ten years after moving into a new church, the Floris Methodist Church members found they had once more run out of space. In December 2004, more than 2,000 came for Christmas Eve services, and on Easter Sunday 2005, over 1,600 attended. Today the congregation is well on its way, with a new building on Frying Pan Road and to go along with it a great view out and over the community. (PC.)

Herndon, like most of Northern Virginia, has seen both business and residential growth during the past 30 to 40 years. Dulles Airport changed many things, and it has brought new homeowners to the town making it necessary for new developments to be built. Shown here are new town homes being constructed near the original town center. (PC.)

A new Catholic church named Saint Veronica is located on Centreville Road. This church congregation has many dedicated members who have worked extremely hard to have services each week, even though weekday mass had to be held at one place, Saturday classes at another, and Sunday services at a school. Their dedication has paid off, and the church is now holding services. In the fall of 2005, the school was ready for kindergarten through eighth grade. (PC.)

With additional families in the area, a growing number of soccer teams and other sports groups creates a problem with space to practice and play their games. Due to this situation, every vacant space gets picked up; however, sometimes a developer will allow use of land until actual new construction is started. It is said the present plans for this field on Centreville Road will allow a practice field to remain a part of the development. (PC.)

George and Betty Coates worked on a number of farms in the area, but when able to do so, they purchased 10 acres and built their own home. Later they purchased additional acreage and set up a dairy farm, shipping their milk to the Washington market. The farm was sold a number of years ago and is used today by several business concerns. The property is slated for development, along with connected acreage. (PC.)

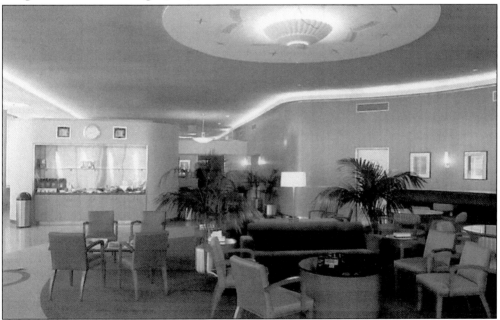

National Airport has also had a name change and is now referred to as "Reagan Airport." The buildings were recently rebuilt and added to, and a new tower was put in place. Some of the new look is of the 1940s, and here a section of the dining area has been set up with furnishings of that period. While making changes, a number of works of art were added to the lobby for passengers and visitors to enjoy. (MWAA.)

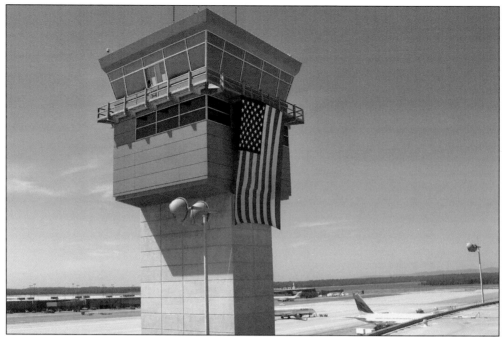

This ramp in mid-field may no longer be needed when the new 330-foot tower is completed; however, this tower may find other uses as the original one by the terminal will be doing. It appears the airport will only continue to grow with airlines, airplanes, people, and equipment, which is needed to keep the business world going and travelers and area residents safe. (MWAA.)

Often it is still a surprise to see such large aircraft appear to just float by. There is a constant mixture in the sky, so one never knows just what will be next—the Cessna following the gas line, an executive jet with the owner on the way to Washington, or perhaps a police or hospital helicopter. Locals stay interested, and the sky stays busy both day and night. (MWAA.)

Here is an aerial photograph of the now-enlarged terminal at Dulles Airport. It is stated Eero Saarinen's original plan was for the building to be this increased size. Not only is the terminal larger, but there are many other structures in place, including additional parking garages, midfield terminals, and a 330-foot tower being constructed that is nearly completed. The entire scene—additional support structures, runways, taxi strips, and high speed turnoffs—make a pattern on the surface. Some of the additional services using space at Dulles are U.S. Customs, Border Protection, the Department of Agriculture, and Immigration Services. In 2004, a new walkway between the main terminal and mid-terminal was completed. Two additional runways were scheduled to be completed in 2005, and additional parking space can now take care of 25,000 vehicles. This view looks south to Chantilly. (MWAA)

The original tower beside the main terminal was impressive with its special radar equipment and the outstanding visibility it allowed those working inside. Although high-tech at the time, today it is too small to accommodate the equipment and staff required to handle the increased traffic at Dulles. The Saarinen tower will remain and be used as needed by ground security. The new tower will be 330 feet tall when completed and equipped with the latest technology for air safety. (PC.)

Smithsonian
*National Air and Space Museum*
*Steven F. Udvar-Hazy Center*

The Udvar-Hazy Museum opened on December 6, 2003, to a large group with invitations, and then opened on December 15 to the general public. There were also other affairs to thank those who had made contributions to the museum. The buildings have been placed on the smaller Fairfax County portion of the airport, just across from Sully Plantation. The Udvar-Hazy Museum is a wonderful gift to the area and to all who come to visit from elsewhere. (PC.)

This beautiful piece of art greets visitors on their arrival at the new Udvar-Hazy Air and Space Museum at Dulles. This eye-catching work by John Safers of McLean has a surface that reflects the sky, the clouds, and even at times the airplanes. The piece soars in an upward movement as if it too could take off into the sky, while from the base, one looks to the Wall of Honor. (PC.)

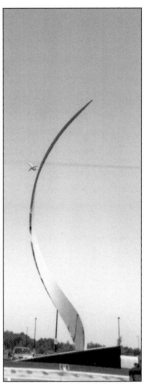

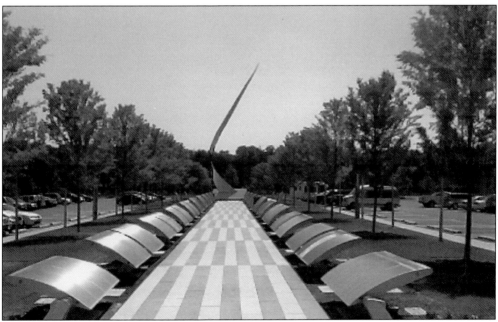

The Wall of Honor has given individuals the opportunity to give a gift to the museum and at the same time to honor someone. Many of those who serve or have served in military service have been named here, as well as those who have an interest in aviation. Names are inscribed on panels along the walkway to the main entrance. A question asked will provide you the location of an individual's name and its placement on the panels. (PC.)

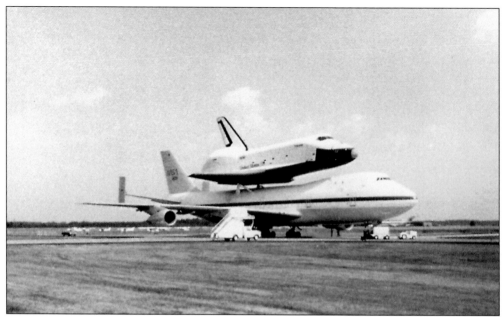

The *Enterprise* was the first space shuttle and is one of the two most exclaimed-over exhibit pieces at the museum. The shuttle was placed on a Boeing 747 and used to train the astronauts to land. This shuttle was not equipped for space flight and did not fly in space. The *Enterprise* was given to the Smithsonian Institution in 1985, and this photograph was taken in June 1987. (ML.)

The Smithsonian had a way of moving the exhibit pieces in without fanfare, and it was exciting when one flew right by on its way to the museum. When the *Enterprise* was moved to its new home at Dulles Airport, the Mullally family had the opportunity to pose beside this special aviation piece. Pictured here are, from left to right, Celeste and Vinny in the back row; and their children, Brandon, standing; and Whitney, held by her mother. (ML.)

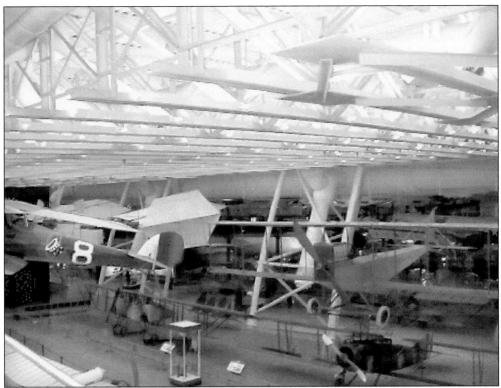

One is almost overcome when entering the main floor or the walkway at the sight of such a vast collection. For those interested in airplanes, aviation, space programs, or military and civil aircraft, this is the place to be. The huge hanger is filled with interesting pieces on several levels. In addition, there are exhibit boxes and cases filled with support materials. The *Enola Gay* is fully restored, and the Blackbird, the fastest airplane ever built, has center stage. (PC.)

To get a bird's-eye view of a portion of Fairfax and Loudoun Counties, take an elevator ride to the tower. Sugarloaf Mountain is to the north, while Herndon and Reston landmarks are in sight a bit to the east. The Sheridan Hotel, big office buildings, Herndon's water towers, and J. B. Franklin's old silo are among structures that can be picked out. Chantilly to the south and Pleasant Valley to the west round out the scene. (PC)

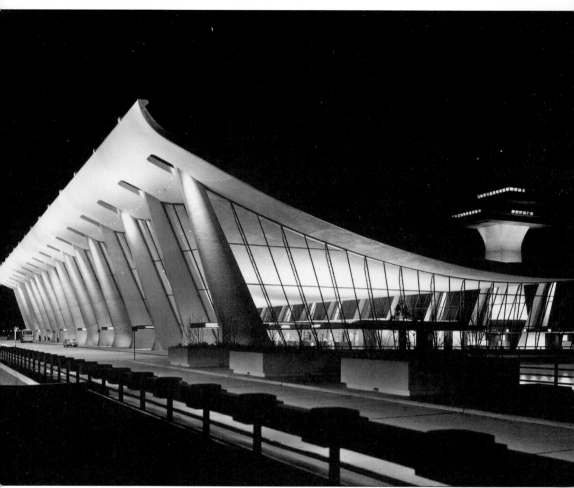

There is a little rise as you drive out the Dulles Toll Road on your way to the airport that provides a wonderful view to the west. At night, with all the lights, it could be Christmas, and by day or night when the snow has fallen, it is a fairyland. Dulles truly does serve as a "Gateway to Northern Virginia." The foothills in Loudoun are visible, and beyond that line can be seen the other ranges. The many structures on the grounds have changed the view and tell a story of what has taken place during the past 40-plus years. More than one individual stated in 1962 that in 30 years, the area would be very busy and very different. Anyone living in the area would have to agree that it has changed. The terminal no longer stands alone, and a "white elephant" no longer lives in the neighborhood. (SF.)

# ABBREVIATIONS

A/BB Austin and Ben Bradley
BC Bernard Cross
CL Clara Leigh
HM Hazel Murphy
JP Jean Packard
MB Mary Browne
MK Michael Kephart
ML Mary Lowe
MWAA Metropolitan Washington Airports Authority
PC Peck Collection
SBF Suzanne Bell Fitcher
SF Sully Foundation, Ltd.
SW Stewart Weller
TF Tom Fletcher
TH Thom Hanes
WH William Hummer
Photographs have been reprinted by permission from the above.

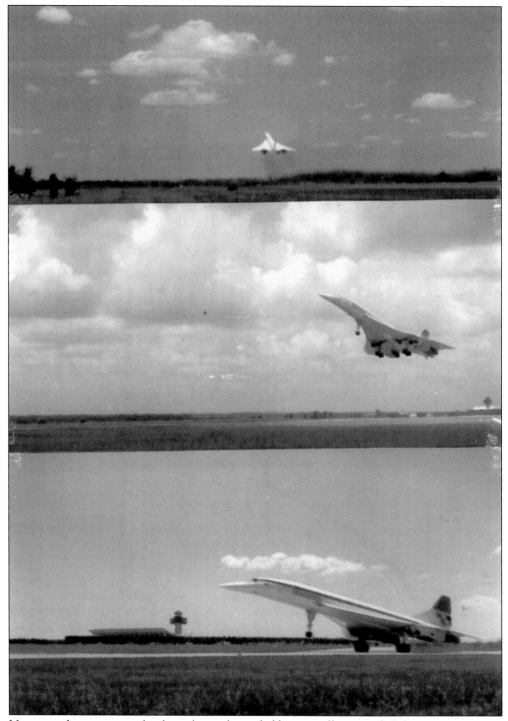

Up, up, and away seem to be the only words needed here to tell a story. (ML.)